D1028971

743302

759.4
W34p

GILBERT M. SIMMONS LIBRARY
Kenosha, Wisconsin

———

1. ADULT books may be retained for two or four weeks
with ONE RENEWAL, unless in demand. New 7 day fiction
and new non-fiction MAY NOT BE RENEWED.

2. JUVENILE books may be retained for two weeks with
ONE RENEWAL, unless in demand.

3. A four day, fine-free grace period is granted. A fine of
two cents per day, including Sundays and holidays, begins on
the 5th day. If the fine is not paid when the material is re-
turned, a service charge is made.

**PLEASE RETURN YOUR BOOKS ON TIME SO
THAT OTHERS MIGHT ENJOY THEIR USE.** DEMCO

JUL 5 1974

Art in Context

Watteau: A Lady at her Toilet

Art in Context

Edited by John Fleming and Hugh Honour

Each volume in this series discusses a famous painting or sculpture as both image and idea in its context – whether stylistic, technical, literary, psychological, religious, social or political. In what circumstances was it conceived and created? What did the artist hope to achieve? What means did he employ, subconscious or conscious? Did he succeed? Or how far did he succeed? His preparatory drawings and sketches often allow us some insight into the creative process and other artists' renderings of the same or similar themes help us to understand his problems and ambitions. Technique and his handling of the medium are fascinating to watch close up. And the work's impact on contemporaries and its later influence on other artists can illuminate its meaning for us today.

By focusing on these outstanding paintings and sculptures our understanding of the artist and the world in which he lived is sharpened. But since all great works of art are unique and every one presents individual problems of understanding and appreciation, the authors of these volumes emphasize whichever aspects seem most relevant. And many great masterpieces, too often and too easily accepted and dismissed because they have become familiar, are shown to contain further and deeper layers of meaning for us.

Art in Context

*Jean-Antoine Watteau was born in Valenciennes, where he was baptized
10 October 1684. He was the second son of a master roofer and
carpenter. He studied for a short time with a local painter in Valenciennes
before going to Paris in 1702. From around 1705 to 1707 he worked
with Claude Gillot and afterwards, for some time with Claude Audran.
In 1709 he competed for the Prix de Rome but won only second prize.
In 1712, his work having come to the attention of Charles de La Fosse, he
was presented for admission to the Académie Royale. La Fosse also
introduced him to Pierre Crozat, whose collection of paintings and drawings
Watteau studied, and for whom he painted the 'Seasons' around
1715-16. In 1717 he submitted his* Pilgrimage to Cythera *as his reception-
piece to the Académie Royale. In 1719, suffering from tuberculosis, he
went to London, possibly to consult Dr Mead about his health. Back in
Paris in 1720 he painted, that year or early the next, the* Signboard
*for the art dealer Gersaint. In the spring of 1721 he went to Nogent, just
outside Paris, for his health. He died there 18 July 1721 at the
age of thirty-seven.*

*A Lady at her Toilet (La Toilette) in the Wallace Collection, London,
is painted in oil on an oval canvas ($17\frac{1}{4}$ x $14\frac{1}{2}$ in.). At an unknown
date it was laid down on a rectangular relining canvas ($18\frac{1}{4}$ x $15\frac{1}{4}$ in.) and
the corners were painted in. There is one drawing by Watteau for the
painting and several others are closely related to it. Although there is no
documentation for its date, available evidence indicates that it was
painted about 1716-17. It entered the collection of Richard Wallace in 1869.*

The Viking Press New York

Watteau: A Lady at her Toilet

Donald Posner

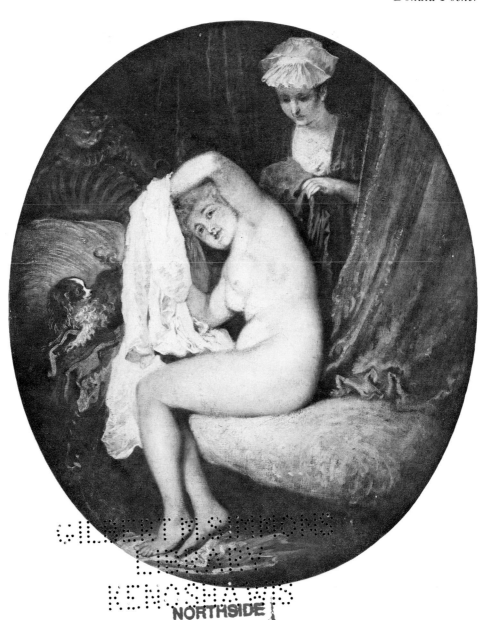

GILBERT SIMMONS LIBRARY KENOSHA, WIS. NORTHSIDE

3 0645 1781422

743302

Copyright 1973 in all countries of the International Copyright Union by Donald Posner

All rights reserved

Published in 1973 by The Viking Press, Inc.

625 Madison Avenue, New York, N.Y. 10022

SBN 670-75173-1

Library of Congress catalog card number: 72-84124

Filmset in Monophoto Ehrhardt by Oliver Burridge Filmsetting Ltd, Crawley, England

Color plate reproduced and printed by Colour Reproductions Ltd, Billericay, England

Printed and bound by W. & J. Mackay Ltd, Chatham, England

Designed by Gerald Cinamon

159.4
W34p

GILBERT M. SIMMONS
LIBRARY
KENOSHA, WIS

For Kurt and Charlotte

Reference color plate at end of book

Historical Table

1709	War of Spanish Succession. Marlborough and Prince Eugene defeat French at Malplaquet. Winter of Great Famine follows in France.
1710	Destruction of Port-Royal.
1711	Death of the Dauphin.
1712	
1713	Peace of Utrecht ends War of Spanish Succession. Bull Unigenitus condemns Jansenist tendencies.
1714	Peace of Rastadt between France and the Emperor. Queen Anne succeeded by George I.
1715	Death of Louis XIV. Philippe d'Orléans becomes Regent.
1716	Establishment of the Law Bank in Paris.
c. 1716–17	
1717	Formation of Triple Alliance (France, England and Holland). Creation of the Mississippi Company.
1718	Austria joins Triple Alliance. Cellamare Conspiracy.
1719	
1720	South Sea Bubble bursts; collapse of Law System; national bankruptcy in France.
1721	

Watteau wins second prize in Prix de Rome competition with his *David and Abigail*.		1709
Gillot presented for membership in the Académie Royale.	Berkeley, *A Treatise Concerning the Principles of Human Knowledge*. Leibnitz, *Théodicée*.	1710
	Shaftesbury, *Characteristics*. Steele and Addison begin the *Spectator*. Death of Boileau.	1711
Watteau exhibits the *Jealous Ones*. La Fosse supports his presentation for membership in the Académie Royale.	Pope, *The Rape of the Lock*. Handel goes to London. Birth of Rousseau.	1712
Watteau is probably introduced to Crozat this year or next.	Marivaux: *Les aventures de****, *ou les effets surprenants de la sympathie*. Birth of Diderot.	1713
Watteau probably meets the Comte de Caylus.	Leibnitz, *Monadology*.	1714
Gillot received as a member of Académie Royale. Watteau probably painting the Crozat 'Seasons'.	Lesage, *Gil Blas*. Richardson, *An Essay on the Theory of Painting*. Death of Fénelon.	1715
Death of La Fosse. Sebastiano Ricci in Paris and meets Watteau.	Commedia dell'arte players allowed to return to Paris. Death of Leibnitz.	1716
Watteau, *A Lady at her Toilet*.		*c.* 1716–17
Watteau submits *Pilgrimage to Cythera* to Académie Royale and is received as a member.	Birth of Winckelmann.	1717
	Voltaire, *Oedipe*.	1718
Watteau goes to London.	Abbé Du Bos, *Réflexions sur la poésie et la peinture*. Defoe, *Robinson Crusoe*.	1719
Watteau returns to Paris from London. Rosalba Carriera in Paris and meets Watteau. Pellegrini in Paris and paints a ceiling in the *Banque de France*. Watteau paints *Gersaint's Signboard* this year or next.	Marivaux, *Arlequin poli par l'amour*.	1720
Death of Watteau.	Montesquieu, *Les lettres persanes*.	1721

Introduction

Antoine Watteau's *Lady at her Toilet*, or *La Toilette* as it is also called, in the Wallace Collection in London [color plate] has always been enthusiastically admired. It has never seemed necessary to say a great deal about it, however, because the small painting is apparently uncomplicated in theme and organization, and because it 'speaks' to us with such wonderful directness. Lady Dilke thought she had said sufficient when she remarked that it contains the most 'beautiful piece of flesh-painting in the whole of Watteau's work'.[1] It is a measure of the picture's power to communicate its beauty that Edmond de Goncourt, who never saw the original, was able to recognize in the pose of the woman, merely from a quick sketch his friend Burty had made after the painting, 'a consummation of grace'.[2] Of course, such comments take a good deal for granted, for they presuppose the beholder's intimate familiarity with Watteau's works and with the art of the early eighteenth century. However, it needs only a little attentive looking, not special knowledge, to be captivated by the sensuous charms of Watteau's small masterpiece.

The leit-motiv of Watteau's picture is, in fact, the intimate appreciation and revelation of beauty. A woman is seated on a bed; the steady gaze of a maid, the lively glance of a spaniel, and the fixed look of a carved cupid all converge on her. She, as if turning the force of their attentions outward, swings round as she pulls a chemise over her head to look full-face at the spectator. Her flesh, against the petal-whiteness of chemise and bedclothes, is roseate in the reflection of hot, brilliant red draperies. Her arms are open and her body is yielding, welcoming, as she reveals herself.

The voluptuousness of this image is sustained by an extraordinary coloristic and compositional lyricism. A resonant harmony is

sounded by a color scheme that rises from deep browns and warm golds up to hot reds and brilliant white, and that has its central notes in the pink flesh and blonde hair of the nude woman. She is enveloped by patterns of repeated colors: those of the draperies; of the headboard and the garment the maid holds; of the maid's dress and hat, the dog's coat, and the floor and foot of the bed. At the far left in the painting the bedclothes are toned to cool grey, and the blue garment on which the dog frolics sounds an isolated color note. From this point, where the forms are in shadow, the composition sweeps forward, out and to the right, in a surge of increasing brightness. The angle of the bed and the rising line that links the dog and the maid define a funnel-shaped volume of space into which the woman, as she leans back, seems to draw the beholder.

The woman is deliciously fair; her plump, firm body is lovely and desirable; her large eyes and cupid's-bow lips are enchanting. She holds us with her gaze – and, with a wonderful musicality, the composition expands in widening circles out from her round face, itself framed by the oval of her arms. The forms in the picture, as if responding to its central oval and to the oval of its frame, fall into patterns of arcs and spiraling curves. The sweep of the drapery at the right merges with the rounded line of the woman's thigh. The contour of her back and arm bends into the curve of the headboard. Long, arching movements swing across each other, branch out to create new, shorter arcs, and at points where they touch the picture's perimeter the controlling curve of the frame catches them up and carries them on. Even the artist's handling of paint collaborates in creating the picture's rhythms and connective patterns. After swiftly describing the dog's fur and playing over the blue garment [1], for instance, his hand seems barely to have paused to change brush and pigments before swinging down along the curved frame, skipping across the cloth on the floor and, touching the leg of the bed with a highlight, rising over the mattress into the red drapery folds, which have an animation that mirrors the excitement of the dog on the opposite side of the painting.

1. True-scale detail of
A Lady at her Toilet. Watteau,
c. 1716–17

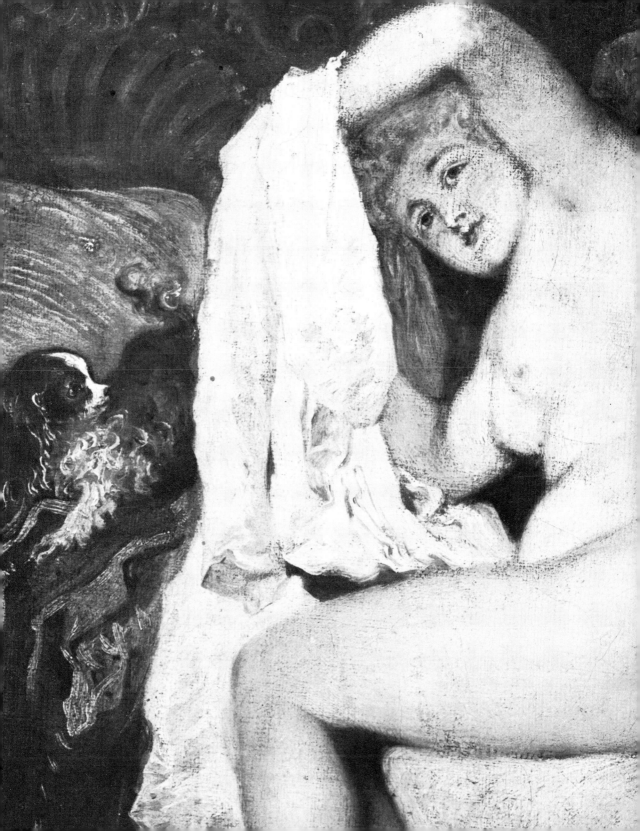

While it is easy to appreciate the rare formal perfection of the *Lady at her Toilet*, other aspects of the picture are more difficult of access. The exact nature of its content is hardly clear. One cannot immediately say what precisely is happening in the painting or what some of its details are meant to signify. Furthermore, there are problems concerning its origin, sources, and date that have to be resolved. Only by answering these questions can we understand the full meaning and poetic distinctiveness of the painting.

1. The Lady and Watteau's Art

The *Lady at her Toilet* was bought by Richard Wallace at the Maison sale in Paris in 1869. Surprisingly, nothing is known of the picture's history before it was in the collection of Marquis Maison, when it had still not acquired its present renown. Suggestions that have been made about earlier ownership are either incorrect or cannot be substantiated.[3] We know only that in the eighteenth century the painting had some influence in France, occasionally serving as a source of inspiration for other artists (see pp. 49, 87-92), and that at least one copy was made after the picture then.[4] Of course, no one has ever dreamed of doubting its authenticity, and it is universally accepted as one of the masterpieces of Watteau's mature period. But beyond this there is no certainty and little agreement. Dates of about 1717 and 1719-20 have been suggested for the picture.[5] The difference is rather disconcerting since the two dates correspond to what otherwise seem relatively well-defined moments in Watteau's career; the former marked by his submission to the Académie Royale of his famous *Pilgrimage to Cythera* and the latter by his trip to England and his creation of *Gersaint's Signboard* on his return to Paris. However, Watteau never dated any of his paintings and external evidence for dating is extremely meagre. Although we may have some confidence about placing most of his works in one period or another of his career, only a very few of more than two hundred extant or recorded paintings can be assigned with any real assurance to a specific date.

Another obstacle to the dating of Watteau's works is the sad fact that a great number of them are in a poor state of preservation. The Wallace Collection picture is no exception. Parts of its surface, not-

ably in the figure of the maid and of the woman herself, have been considerably damaged. Minor losses can be seen everywhere on the nude body, where the paint originally was relatively thin and the handling especially subtle. Cleaning and abrasion have made the ground and the grain of the canvas visible in places, and these areas distort some contours and show up as unsightly rough patches on the woman's young flesh. However, the freedom, breadth and animation of Watteau's brushwork are still in brilliant evidence in the painting of the dog, the cupid, and the draperies and clothing. Unfortunately, the picture's handling is not, in any event, a very accurate index of date in this instance, for it can easily be paralleled in either the *Pilgrimage to Cythera* of 1717 or in *Gersaint's Signboard* of 1720-21. There is, however, other evidence that can be brought to bear on the problem of dating and that also helps us to answer the question of how the picture came into being.

The *Lady at her Toilet* is fairly unusual in Watteau's *oeuvre* in representing a nude figure within an oval frame. It is true that the picture has been exhibited and sometimes illustrated as a rectangular work, and there are other paintings by Watteau that have, in the course of their history, also been put in differently shaped frames. Sometimes, because the composition seems about equally effective in either an oval or a rectangular format, one cannot be absolutely sure what kind of frame the artist wanted.[6] But Watteau seems certainly to have planned the Wallace Collection picture to be seen as it is today. Its framing was changed at an unknown date before 1869 when the oval picture was pasted on to a rectangular canvas and the corners painted in by a hand clearly other than Watteau's.[7] When the picture is taken out of its frame [2] these corners present themselves as dead areas falling outside the field of compositional activity. Worse, the additions dissipate the energy of the design, so that the image takes on something of the appearance of a coil gone slack. Seen within the oval frame, the composition seems to spiral, opening out from its centre, reaching out toward the spectator and drawing him in.

2. *A Lady at her Toilet*
(without frame).
Watteau, *c.* 1716-17

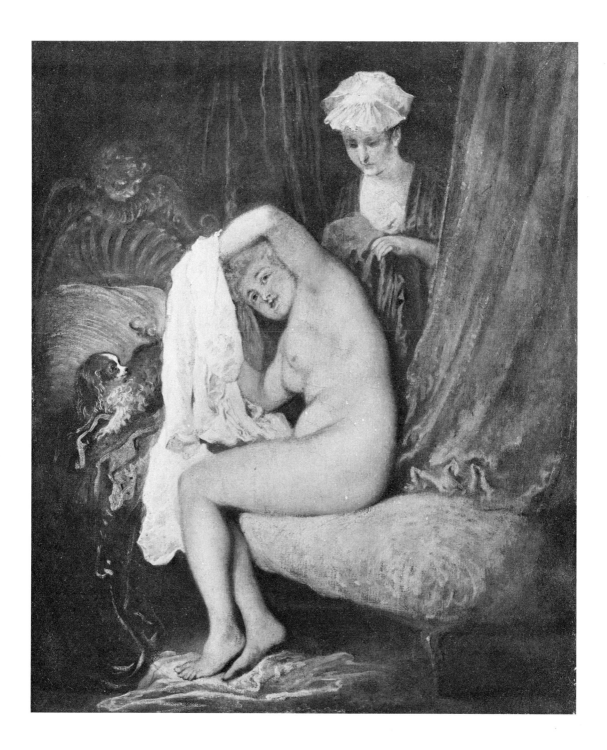

The problem of relating figure pose and movement to the continuous curved line of a surrounding frame has intrigued artists since the beginning of the Renaissance, when Raphael found what has come to be seen as the 'classic' solution in his *Madonna della Sedia*.[8] Raphael and other artists of the early and high Renaissance formulated the problem in terms of the *tondo*, the circular format. Watteau used, instead, the oval shape, a favourite form in eighteenth-century art and one that had become popular in the late Renaissance period, when Veronese, for instance, made brilliant use of it in his decorations. However, both circle and oval pose essentially the same problem for the figure painter intent on imitating nature faithfully while still endowing his forms with the 'grace' of art: the figures must appear unconstrained, natural in their posture and action; yet they must be ordered by the rigorous dictates of a scheme imposed by the shape of the frame. This special design problem confronted Watteau as a major challenge when the financier and art lover Pierre Crozat commissioned him to paint four large (about 57 in. high) oval representations of the 'Seasons' to decorate the dining-room of his Paris house.

Apparently, only one of the 'Seasons' survives today, *Summer*, in the National Gallery in Washington, but another, *Spring*, is known from a photograph,[9] and all four compositions are reproduced by

3 *(far left)*. *Winter*.
Engraving by J. Audran after Watteau, *c*. 1714–15

4. *Summer*. Watteau, *c*. 1715

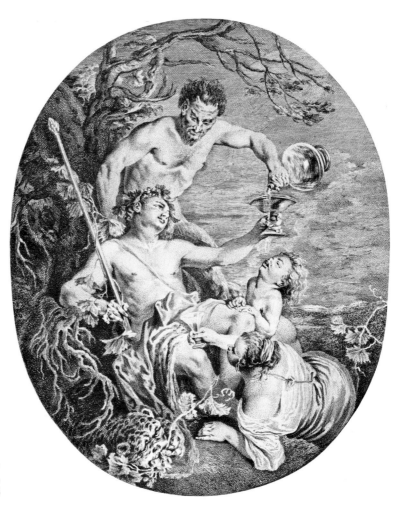

5. *Autumn.*
Engraving by E. Fessard after Watteau,
c. 1715–16

eighteenth-century engravings. The paintings show a clear develop-
mental sequence, a progress from the tentative and rather awkward
Winter [3] to the more graceful, but compositionally less ambitious,
Summer [4], to the elaborate and harmonious *Autumn* [5], to the
almost magical achievement that is *Spring* [6]. Our illustration of
Spring shows it after it had been slightly cut down. This alteration
resulted in the loss of the season's zodiacal signs of the ram, bull
and twins at the left side of the picture, which marginally impairs
the effectiveness of the composition. But this in no way hampers

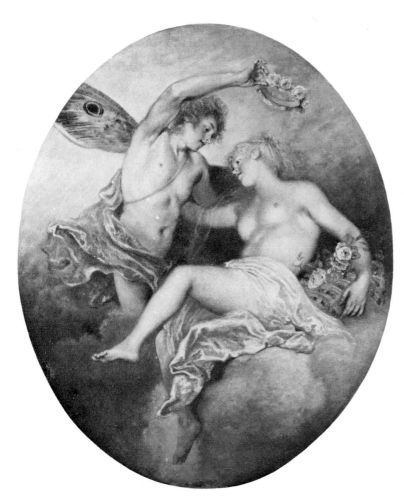

6. *Spring.* Watteau, *c.* 1716

one's appreciation of the work's formal beauty. The interlaced limbs of the figures, so perfectly expressive of the loving union of the flower-goddess and the springtime breeze, the soaring arc of Zephyr's arm, rising like the wafting wind, the inclined head of Flora, the large rounded shapes of her breasts, even the arched curve of her foot – all are delightfully natural in appearance and beautifully integrated parts of an orchestration of curvilinear forms and movements whose main melodic line is set by the oval frame.

Evidently, some time must separate the paintings of *Winter* and *Spring*, and it has been suggested that a longish time may have

elapsed between the artist's receipt of the commission for the four works and his completion of the last picture. In fact, one wonders if Pierre Crozat was not thinking of his 'Seasons' when he wrote in December 1716 to the Venetian painter Rosalba Carriera that if Watteau 'has a failing, it's that he takes a very long time with everything he does'.[10] The challenge presented by the oval 'Seasons' must have been Watteau's major preoccupation during a period of at least two or three years. It seems only natural that he should have made other paintings at the time that also take up the problem of arranging large nude or semi-nude figures in an oval format. There are, in fact, three works by Watteau, generally thought to be roughly contemporary with the 'Seasons', that do just that: *Cupid Disarmed by Venus* [7] in the Musée Condé, Chantilly; *Autumn* and *Jupiter and Antiope* in the Louvre. For the artist these oval pictures were, on one level certainly, exploratory probes by which he examined the formal problems set by the 'Seasons' commission and tested ideas for their solution.

The Chantilly *Cupid Disarmed* and Louvre *Autumn* belong to a fairly early stage in the problem-solving process, probably to be located at a point around the time of *Winter* or just before *Summer* from the 'Seasons'. *Cupid Disarmed*, for instance, is conceived largely in terms of a two-dimensional configuration that is almost diagrammatic in suggesting a wheel and spoke-like structure, and that in consequence gives an impression of stiffness and artificiality. In the stage that includes the Louvre's *Jupiter and Antiope* and Crozat's *Autumn* and that culminates with *Spring*, the forms arrange themselves more naturally in response to the overall rhythms of the design. What is more, the controlling oval scheme is now effectively extended so that it encompasses the space as well as the surface of the picture. Figures are turned into depth, heads and bodies are inclined, set on angles to the picture plane, and tied by curved spatial patterns of shape and movement to the curved frame. The result is a wonderful sequence of formal elements that unfold like the petals of a blossoming flower.

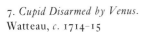

7. *Cupid Disarmed by Venus.*
Watteau, *c.* 1714–15

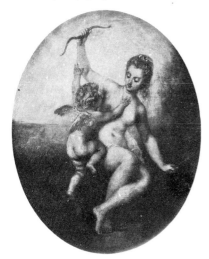

Besides the three pictures mentioned above, the *Lady at her Toilet* is the only painting by Watteau that addresses itself, like the 'Seasons', both to the representation of the nude figure and to the problem of oval design. It too, therefore, is probably in part a by-product of Watteau's work on the Crozat commission. There can be no question, of course, but that the Wallace Collection picture, with its utter effortlessness of arrangement and absolute concordance of two- and three-dimensional organization, stands at the same level of artistic accomplishment as *Spring*. These considerations suggest that it is contemporary with *Spring*, and several other factors support such a conclusion.

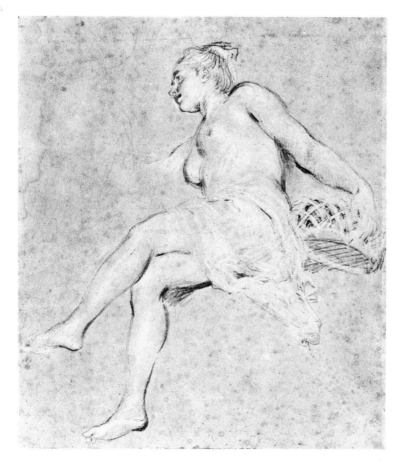

8. Study for *Flora*. Watteau, *c.* 1716

The woman in the Wallace Collection painting, leaning back and presenting a foreshortened view of her breasts, is posed remarkably like Flora in *Spring*. The resemblance is even more striking when the pose of the lady is compared to that of the goddess in Watteau's preparatory drawing for Flora [8], before the artist adjusted the form in order to relate it intimately to Zephyr and to the shape of the frame. The device of circling the figure's head with its raised arm was not used for Flora, but it appears in a somewhat different form in Zephyr's pose in the painting. A very similar conceit is found in one of Watteau's most voluptuous drawings of the nude [9]. Here, in its angle and posture, the torso virtually mirrors the pose of the

9. *Study of a Woman Nude to the Waist.* Watteau, *c.* 1716

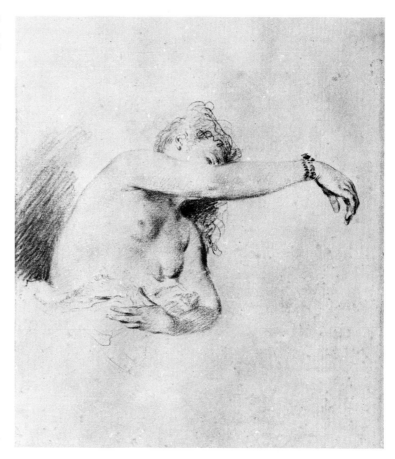

woman at her toilet. It seems logical to suppose that this group of images belongs to a single constellation of ideas, related in time as well as in form. It is true that the study for Flora has generally been placed earlier than the drawings by Watteau that can be connected with the *Lady at her Toilet*,[11] but this dating appears to be based more on assumptions, to my mind unjustified, about the relative dates of the two paintings than on any demonstrable differences in the style of the drawings.

In other respects too, the *Lady at her Toilet* has close affinities with *Spring*. The painterly and luministic treatment, allowing for the difference in size between the two works, is very similar. The radiance that falls on the firm flesh of the nude figures is the same. The brushwork is virtually identical: one need only compare the draperies of Zephyr and Flora and Flora's basket of flowers with the curtain and dog in the smaller picture. Even more important, the lady and Flora represent the same ideal of feminine beauty. Full-bodied, a little plump, these women differ markedly from the tall, slender figures typical of Watteau's late paintings, such as *The Judgement of Paris* [36], which is generally dated around the time of *Gersaint's Signboard*. These more opulent ladies differ, too, from the delicate, small-boned women who appear in his early works, like the *Jealous Ones*, which the artist showed to the Académie Royale in 1712.[12] Flora, of course, with her prettily pointed nose and saucy air, is, unlike the Wallace Collection woman, a charming *gamine*. But a comparison of the painting of *Spring* with Watteau's preparatory study for Flora shows that, in the finished work, 'art' has intervened in order to express the youthful spriteliness of springtime. In the drawing, Flora seems much the same age and type as the woman who appears in the *Lady at her Toilet* and in related sketches by Watteau [23, 25–9]. Significantly, the figure of Ceres in the Crozat *Summer* [4] also resembles this woman closely, and it is not unlikely that the same blonde model served for all these works.

The most obvious formal difference between the *Lady at her Toilet* and *Spring* is in their color and value scale. The former is

warm, deep-toned and dominated by reds and golds. It is clearly inspired by Titian's palette, and may in fact be based directly on the version of Titian's *Danaë* that was once in Crozat's collection and is now in the Hermitage [10].[13] The two paintings are extremely

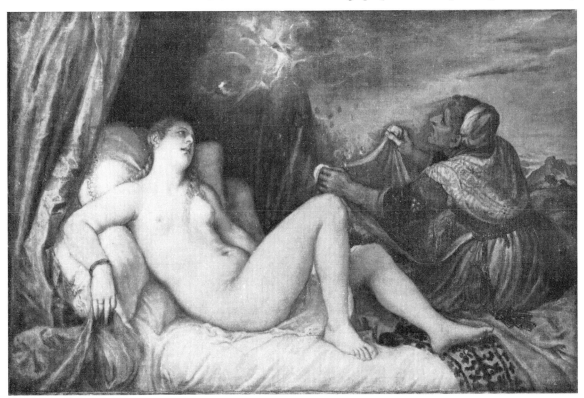

10. *Danaë.*
Titian and assistants, after 1553

close in color and there is a formal and poetic concord between them which is not likely to be accidental. *Spring* is very different: blue and white set off Flora's fair skin and hair, and the painting's silvery, high-keyed tonality evidently depends on the colorism of Veronese.[14] This difference has a meaning, but not that the pictures belong to different periods in Watteau's career. In fact, their particular sources of inspiration and the force with which they manifest themselves are strong evidence of their contemporaneity.

When the young Watteau, about eighteen years old, came to Paris in 1702, the little artistic culture he possessed was Nether-

landish. His native Valenciennes was really a Flemish town that had only been ceded to France in 1678 by the Treaty of Nijmwegen.[15] His earliest contacts in Paris were with the Netherlandish community in the city, and he began his career there by making copies of works by the Dutch and Flemish 'little masters'. During the next decade his experience widened considerably, but it was not until his association with Pierre Crozat that the Italianate grand manner of the sixteenth and seventeenth centuries had a truly profound effect on him. Crozat amassed an immense collection of paintings and drawings by the time he died in 1740. (Most of the paintings ultimately went to the Hermitage.) The composition of the collection when Watteau was introduced to him is not known, but it must already have been impressive, for by 1700 Crozat had gained a reputation as an *amateur*. Crozat belonged to a group of art-lovers who were dedicated partisans to the coloristic styles of North Italy and of Rubens and his school. His great personal passion was Venetian art and especially the works of Veronese. Naturally, he was partial to artists of his own time who shared his tastes;[16] one of them, Charles de La Fosse, lived in Crozat's Paris house. La Fosse, who is said to have 'discovered' Watteau in 1712, probably introduced him to Crozat and suggested him for the 'Seasons' commission.[17] For a brief period Watteau too accepted lodgings from Crozat. It is not known exactly when this was, but the date is perhaps not too important since Watteau must have been a frequent visitor to Crozat's house even when he was not actually living there.[18]

Watteau immersed himself in a study of Crozat's treasures. Their influence is plainly revealed in the 'Seasons' and in related works. *Spring*, *Summer* and *Cupid Disarmed* owe their color and tonality to the impression Veronese's paintings made on Watteau. *Cupid Disarmed* is also based on a drawing by Veronese that Crozat owned.[19] The pose of Zephyr and the pose of the woman in Crozat's *Autumn* were inspired by figures in Titian's *Andrians*, and two of the other figures in *Autumn* derive from Rubens's *Bacchus on a Barrel*, now in the Hermitage and formerly in Crozat's collection.[20]

Jupiter and Antiope depends on Van Dyck and on Titian.[21] The pose of the woman in the Wallace Collection picture recalls figures in works by Rubens and Veronese.[22] It is clear that for a time Watteau drew on and was deeply impressed by the wide range of Venetian and related works available to him in Crozat's collection. The particular source that dominates in any of these paintings by Watteau is not an indication of date; the source was chosen because it best suited the project at hand. *Spring*, silvery and airy, conveys the gaiety of youth and the sunshine brillance of the season. The *Lady at her Toilet*, like the *Jupiter and Antiope* and probably like Crozat's *Autumn*, is warm and deep in color to communicate passion and the heat of sensual desire.

The 'Seasons' cannot be dated precisely. They are, of course, after 1712, when Watteau first came to La Fosse's attention. They have been dated as early as around 1713, but this seems improbable for, judging from the stiff forms and arrangements of works by Watteau that can be placed about 1712, like the *Jealous Ones*, the 'Seasons' must be assumed to date at least two or three years later. Almost certainly they were completed by 1717, when Watteau finished the *Pilgrimage to Cythera* and when he reached a new level of artistic maturity, having fully assimilated the lessons of the masterpieces in Crozat's collection. Recent opinion tends to date the 'Seasons', as a group, around 1715, and Michael Levey has made the very reasonable suggestion that the commission for the series may date from 1713–14 and their actual execution from 1715–16.[23] *Spring* is in style the most advanced of the 'Seasons'. The *Lady at her Toilet*, so intimately connected with the 'Seasons' in origin, and so close in style to *Spring*, should be dated about 1716–17.

The genesis of the Wallace Collection picture can be understood partly in terms of special formal problems that Watteau was forced to deal with at a particular moment in his career. However, there remains the question of its subject and presentation; in this respect the picture differs in a fundamental way from the 'Seasons' and from the other oval paintings we have discussed.

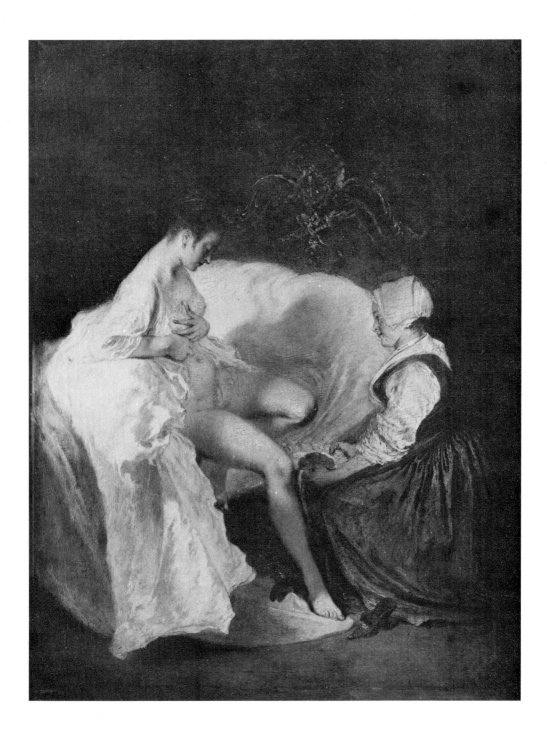

2. The Lady
and Watteau's Erotic Pictures

The *Lady at her Toilet* was not included in the huge corpus of prints after works by Watteau published between 1726 and 1738 under the auspices of Jean de Jullienne, Watteau's long-time friend and great admirer.[24] However, it is hard to imagine that Jullienne was not familiar with the painting and with others like it. It is hardly possible, for instance, that he did not know *The Morning* or *Intimate Toilet* [11], at least from the print made after it by Mercier.[25] But *The Morning Toilet* was also excluded from the *Recueil Jullienne*. I suspect that Jullienne's omission of these works was not accidental. It is known that Jullienne, contrary to his announced aim of recording every painting by Watteau, deliberately excluded some, such as early pictures that copy or imitate other masters, that were apparently in his opinion of little interest or value. Other pictures, including such famous works as the Louvre's *Gilles* and *The Gathering in a Park*, were inexplicably omitted.[26] But it seems to me probable that the Wallace Collection picture and related works were excluded because of their subject matter. Jullienne would not have objected merely to the representation of a naked woman, for several pictures with nudes do appear in the *Recueil*. All of those that do, however, are mythological or allegorical works such as *Diana at her Bath*, *The Rape of Europa*, the Crozat 'Seasons' and *Cupid Disarmed by Venus*. Pictures of this kind were of unquestionable respectability, for they belonged to the highest aesthetic category, 'history painting', and they had always been part of the standard repertory of great artists. However, naked women, neither goddesses nor personifications, in ordinary domestic settings and situations were quite

11. *The Morning Toilet.*
Watteau, *c.* 1715

another matter; Jullienne may well have felt that they were not really worthy of a great master and that their reproduction in his 'complete corpus' of Watteau's works would tarnish the artist's reputation. This scruple is a little difficult to appreciate today because we have become accustomed to pictures of nudes in every-day settings. Naked ladies are so frequently met in nineteenth- and early twentieth-century painting – whether as women at their toilets [52] or sunning themselves in the out-of-doors as in works by Manet and Renoir, or just posing in the artist's studio, like the 'Odalisques' of Matisse – that we have understandably come to regard them as traditional subject matter for pictures. The tradition was, however, formed only in the eighteenth century.

Before Watteau, representations of the nude figure – often very erotic ones – were considered socially acceptable only if they illustrated mythological, historical, or biblical stories, or if they conveyed, generally through allegory, some useful or moral lesson. Naturally, the educative claims of many such representations were only an excuse for a primarily salacious purpose; and often the artist's audience preferred to let the attractions of erotic form obscure what may have been a genuine didactic content. It appears, for instance, that some paintings of Venus reclining nude, like Titian's voluptuous depictions of the theme, may at one level be statements about the primacy of the 'spiritual' faculties in the perception of beauty. However, the Abbé de Brantôme, the six-teenth-century author of the *Lives of Gallant Ladies*, insisted that there is little difference between paintings of 'a stark naked Venus lying down with her son, Cupid, looking at her', and 'Aretino's pictures', those infamous representations of the 'postures of love'.[27] But there is a difference, of course, and historically it meant that scenes of pagan gods in amorous dalliance could, on the excuse of antiquarian learning or philosophic content, be displayed and admired publicly. On the other hand, the images to which Aretino gave his name (by supplying scandalous verses to accompany them), because they show only how 'dishonest men lie with women', had

to be enjoyed privately. They had, indeed, resulted in imprisonment for Marcantonio Raimondi, who first engraved them.[28]

The history of erotic imagery in art will concern us further. However, it should be noted here that pictures of nude women at their toilets or in other domestic situations gradually came to be accepted in the eighteenth century as the status of genre painting rose in the hierarchy of categories of subject matter. In the nineteenth century, of course, the 'studio' or 'domestic' nude came to seem entirely innocent, largely through the development of a new, romantic conception of art, which was now seen as a pure, disinterested quest for truth through beauty. Art itself became all the excuse such a genre subject might need. The crucial point in our context is that when Jean de Jullienne composed his *Recueil* he had to judge Watteau's paintings by artistic categories and hierarchies that had been set in the seventeenth century. Unlike the master's *Diana at her Bath*, for instance, where the appearance of a quiver of arrows transforms a naked woman into a goddess and the picture into a history painting,[29] the *Lady at her Toilet* was a minor embarrassment for him. Because of its subject, its unashamed and unqualified revelation of the erotic beauty of the nude, it did not fit into any established artistic category and seemed just a little risqué. Evidently, Jullienne though it best to ignore it and its like.[30]

In suppressing knowledge of the *Lady at her Toilet* Jullienne may have taken his lead from Watteau himself. It is reported that in 1721, a few days before he died, the artist insisted on destroying some of his works (almost certainly drawings, though the word used is the non-committal '*morceaux*') which he felt were somehow indecent. This report comes from the Comte de Caylus, a close friend of the master, who asserted that Watteau 'never made an obscene work', and who attributed the episode to an excess of zeal for the requirements of propriety.[31] It is true that 'obscene' would be too strong a word to describe the *Lady at her Toilet*. But it would be a mistake to underestimate the genuine erotic purpose of this painting and, surely, one cannot accept the silly notion that the

exquisite delicacy of Watteau's work derived from some unworldly purity of motives or from a chastity both physical and spiritual.[32] In point of fact, many of the master's *fêtes galantes* are primarily about sensual desire and libidinous passion. But the *fêtes galantes*, where nudity is allowed to tutelary statues only, stay clearly within the bounds of early eighteenth-century expectations of decency. The *Lady at her Toilet* seems to overstep them. And there are other paintings by Watteau that go further in the same direction.

The *Morning Toilet* [11] is a picture that was probably once owned by Louis-Antoine Crozat de Thiers, Pierre Crozat's nephew. This painting seems to have enjoyed a somewhat greater fame before the nineteenth century than did the Wallace Collection picture. A print was made after it early in the 1720s by Philip Mercier (but not for inclusion in Jullienne's *Recueil*), and at least three eighteenth

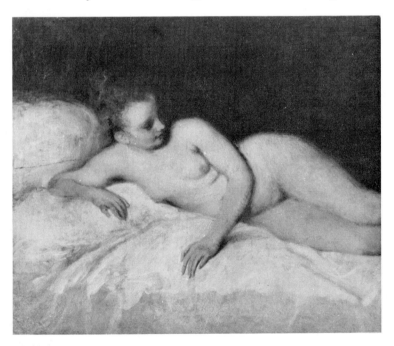

12. *Reclining Nude.* Watteau, *c.* 1714–15

13 *(opposite).* *The Remedy.* Watteau, *c.* 1714–15

century paintings derived from the print.[33] The intimacy of the painting's subject apparently seemed extreme to Mercier. In his print he lengthened the woman's chemise and made it cover more. One of the paintings, in the Valenciennes museum, replaces the sponge in the bowl of water the servant holds with a bunch of grapes – as if to suggest breakfast upon arising! Even in our century some people seem disconcerted by the image. One modern writer, preferring to ignore what he saw, imagined that the servant is about to help her mistress on with her shoes and stockings.[34]

A related picture by Watteau shows a nude woman lying on a bed [12]. The painting is very broadly handled, more like a sketch than a finished work, and it is only a partial or variant rendering of an image created by Watteau in a highly finished drawing where one sees a servant about to administer an enema [13][35] – a sovereign

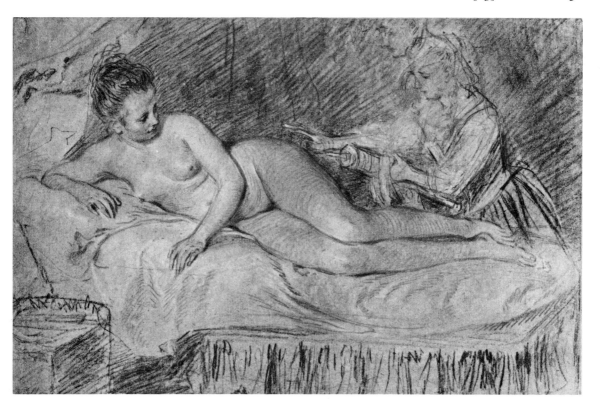

remedy in Watteau's time and which also became one of the most popular of subjects for erotic art later in the eighteenth century.

The *Lady at her Toilet*, *The Morning Toilet* and *The Remedy* are the only known surviving compositions by Watteau of their kind. It seems likely that he made a few others which have since been lost or destroyed. Inventories of now dispersed collections and old sales catalogues occasionally include erotic pictures ascribed to Watteau.[36] Not all the attributions were necessarily wrong. One wonders, too, whether some gallant subjects that appear frequently in the work of Watteau's followers did not have models in pictures by the master. To judge from old notices, the titillating scenes of women bathing that Pater, for instance, so much favored, would have had precedents in Watteau's *oeuvre*.[37] It is also possible that licentious drawings by the master were fairly numerous at one time and that they provided models for paintings by others. Unfortunately, it is unlikely that we shall ever know the whole truth about these matters, but the sparse available evidence indicates that Watteau was somewhat more involved in erotic art than is usually thought.

Seen in the broad context of French culture of the early eighteenth century, the appearance of *erotica* in Watteau's *oeuvre* reflects the development of new social and intellectual attitudes. As a counter-current to the prevailing sanctimony and dullness of life at court during the last years of Louis XIV's reign (largely given its tone by that pious friend of the Jesuits, Madame de Maintenon), new trends, marked by gaiety at the least and by shameless debauchery at the most, were steadily gaining strength in Paris. It was not necessary for Parisians to await the death of the King in 1715 and the appointment of Philippe, Duke of Orléans, as Regent of France, to enjoy a life of considerable social and moral licence. However, as Regent, Orléans provided a model that undoubtedly freed many people from the inhibitions that official decorum had earlier imposed. The Duke – an impious drunkard, a dedicated orgiast, and devoted connoisseur of loose women – set such an extravagantly ambitious example that only the hardiest of people were willing or able to

follow it. He was an extreme case but, as such, symptomatic of the licentious possibilities of the time and of the toleration they enjoyed. Behind them lay ideas and attitudes that had been gathering since the late seventeenth century.

New critical methods of investigation, new discoveries in science, and increasingly detailed reports about life and manners in strange, faraway places, all gradually conspired to undermine the authority of traditional beliefs and morality. There developed a healthy scepticism about received ideas and a refreshing air of toleration for *mores* that were not one's own; scepticism and toleration were to be essential nutrients for the life of the 'enlightened' man of the eighteenth century. It may, for a moment, seem odd to relate erotic or pornographic art to the noble spirit of the Enlightenment. But that they were in fact related is obvious at once when one thinks, for example, of the salacious passages in Montesquieu's *Les lettres persanes*, or of Voltaire's *La Pucelle d'Orléans*, or Diderot's *Les bijoux indiscrets*. Actually, a bias in favor of the erotic was to be expected from anti-clerical, materialistic thinkers. Much of what Church authorities declared morally reprehensible was interpreted by enlightened reason as sexual emancipation. Indeed, the great blossoming of pornography in the eighteenth century was in large part a by-product of the effort to free mankind from the constraints of narrow-minded religious prejudice and of an unreasoning sense of sin. The daring free-thinker and the bold *roué* were both called 'libertines', and both were often found in the same person.[38]

A new licence in the use of erotic materials is found in the pictorial arts in France and elsewhere in the first decades of the eighteenth century. In 1704, for instance, Jean-Baptiste Santerre submitted to the Académie Royale as his reception-piece a *Susanna at her Bath* [14] that might have seemed inadmissible only a generation earlier for its coy suggestiveness. Jean-François de Troy, in a work of 1727 now in the Angers museum, showed Bathsheba in a state of voluptuous abandon that even today seems faintly startling. These paintings and others like them still maintain the fiction of having a biblical

or classical justification, but erotic pictures which seem to be just that and no more are encountered frequently in this period. The works of the minor Dutch master Godfried Schalcken (1643–1706) were then much admired in France. They include toilet scenes and bedroom scenes which, though deriving from earlier Dutch 'Vanitas' and 'Sense of Sight' or 'Touch' representations, really serve only an

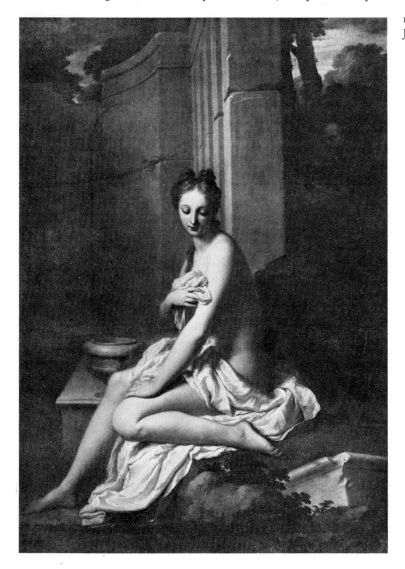

14. *Susanna at her Bath.*
J.-B. Santerre, 1704

erotic purpose. Schalcken's works influenced such artists as Jean Raoux (1677–1734) and Antoine Pesne (1683–1757), whose *Woman in Bed Illuminated by Candlelight* of 1718 [15] shows the direction of this trend very plainly. Pesne, incidentally, was an artist who also absorbed the lessons of Watteau and helped to popularize his work and style in Germany.

15. *Woman in Bed Illuminated by Candlelight.* A. Pesne, 1718

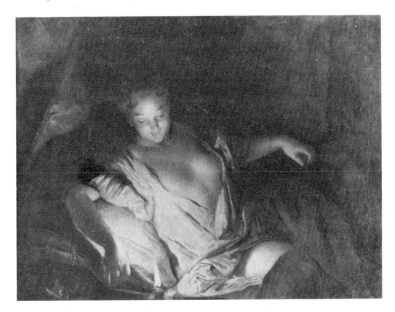

Naturally, plain-spoken erotic representations were not scarce before the eighteenth century.[39] However, as long as their production and possession were considered sinful, they were not really acceptable as 'works of art'. Even in the eighteenth century, as Jullienne's reaction to Watteau's *erotica* shows, they seemed of questionable taste; and, of course, what we call 'hard-core pornography' has never been considered socially acceptable. But what happened around 1700 was that the art market for pictures of high aesthetic quality was able to expand to include some types of erotic art, and reputable artists were thus encouraged to produce them.

Watteau's erotic pictures are comprehensible in terms of the cultural situation of his time, which made such works a real option

for serious artists. The problem for the art-historian, however, is to determine just how Watteau came to take up such subject matter. The question gains a specially sharp focus from the fact that the artist very seldom painted 'gallant' pictures and his decision to do so, therefore, implies that exceptional circumstances inspired him.

The Morning Toilet and The Remedy are in my view datable on grounds of style around 1714–15;[40] that is, they are approximately contemporary with such works as Cupid Disarmed by Venus [7] and Jupiter and Antiope. Like the Lady at her Toilet they are related in time to the Crozat 'Seasons', but they are closer to the beginning, rather than to the end, of work on that project. The representation of the nude figure was necessarily of great interest to Watteau at this time, and he apparently worked assiduously during the period making sketches from life.[41] But to carry such an interest, or such sketches, on into the creation of erotic pictures needed some special stimulus. The artist's activity of sketching from the nude model suggests such a stimulus in the person of the Comte de Caylus, who used to draw and paint after the live model, together with Watteau, in the seclusion of rooms that Caylus had rented in various quarters of Paris.[42]

Caylus is remembered by art-historians mainly as a pedantic antiquarian and as a rather sententious art critic, who blamed Watteau for his lack of sound academic technique and practice and for his inability to compose learned history paintings.[43] But there was another side to the man. Caylus enjoyed early careers as a soldier, adventurer and Parisian rake, and he became the leading spirit of a famous libertine club, the 'Bout du banc', which included such authors of 'gallant' works as Voisenon and Crébillon fils. Caylus was himself a major producer of licentious literature. Twelve volumes of 'oeuvres badines', 'sportive works', were eventually published under his name; he appears to have been general editor of the whole undertaking as well as the author of a good part of it.[44] These writings were done during his maturity, but they surely represent interests

that were already formed in his youth. Caylus first met Watteau, according to his own report, some time after the artist had been accepted by the Académie Royale in 1712. Good arguments have been advanced for placing the meeting of the two men in 1714,[45] when the twenty-two-year-old Caylus gave up his military career and settled in Paris for some months before going on a year-long trip to Italy. This was just about the time that Watteau began work on the Crozat 'Seasons', when the nude figure in general was a special subject of his attention. Caylus was also an amateur painter and he was one of the many art-lovers who frequented Crozat's house. He and Watteau became fast friends. For pleasure they took to drawing and painting together with their mutual friend Nicolas Hénin, in privacy. Caylus reported that Watteau was wonderfully relaxed at these sessions: 'so somber, so bilious, so timid and caustic everywhere else', he was, in this intimate situation, 'agreeable, affectionate, and perhaps a little rustic in manner [*un peu berger*].'[46] One imagines that a certain amount of ribald banter went along with their work, and that they came to make 'private' pictures at their private sessions. One thing is certain: the improper *morceaux* that Watteau insisted on destroying before he died were in the possession of Caylus. Caylus said so in his rough draft for the lecture on Watteau that he read to the Académie Royale in 1748.[47] It is not possible to say whether any of Watteau's three known erotic compositions were made for, or ever owned by, Caylus. It does seem likely, however, that Caylus initially suggested such works to Watteau, and it seems certain that he gave the artist whatever encouragement he needed to make them.[48]

When Watteau took up erotic themes there were, of course, long-established pictorial traditions for him to draw on. Both *The Morning Toilet* and *The Remedy* have sources in earlier representations. Some of the sources were primarily pornographic in nature. *The Morning Toilet* can be related easily to 'popular' images such as a picture of a similar, though not identical, toilet [16]. One finds there, in fact,

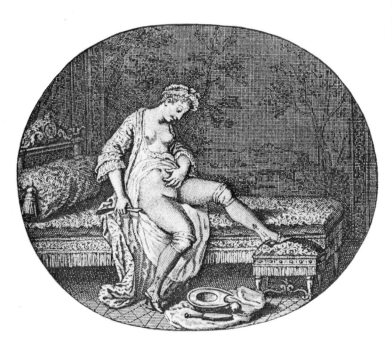

some striking similarities to Watteau's work in pose and setting. However, Watteau does not focus blatantly on the woman as an anonymous sexual object. By the introduction of the maid, the suggestion of the time of day, the intimations of an amorous mood – conveyed by the luxuriant softness of the bed and by the disarray of the bedclothes – he at once heightens the sensual excitement of the scene and avoids the crass impersonality that devalues mere pornography. This larger vision of the possibilities of the theme must have come to Watteau through his knowledge of pictures, mainly prints, of the fashions, furnishings, and manners of contemporary society. Such pictures were extremely popular from the late seventeenth century on,[49] and served as the *Vogue* magazine of their day. In general they were only mildly suggestive, if at all, sometimes showing a woman *en déshabillée* with a deeply plunging neckline. But they included scenes of women upon arising, at their toilets, bathing their

17. *The Foot Bath.*
Engraving by N. Bazin after
Dieu de Saint-Jean, 1685

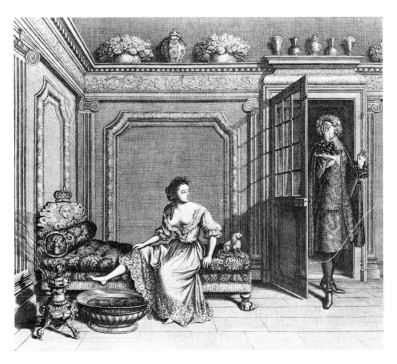

feet [17], or engaged in other charmingly intimate, private activities. In these scenes the women are often accompanied by their servants, or visited by friends, and surrounded by the accoutrements of daily life. Such pictures provided Watteau with a context for his gallant imagery. Indeed, the erotic aura of his paintings radiates from the world of convincing, intimate domesticity.

The Remedy also has its thematic origins in earlier genre scenes. Quite gross renderings of the theme probably existed before Watteau's time, but it is best known to us from works such as a picture by Jan Steen, which shows a visit by a doctor to a sick girl in bed [18]. The painting of an amorous couple on the wall and the statue of Cupid above the door allow us to diagnose her illness as love-sickness, and the inscription on the sheet of paper on the floor tells us that 'no medicine is of help here, for it is the sweet sickness'.[50] Nonetheless, the physician prescribes for her; a leering boy holds up

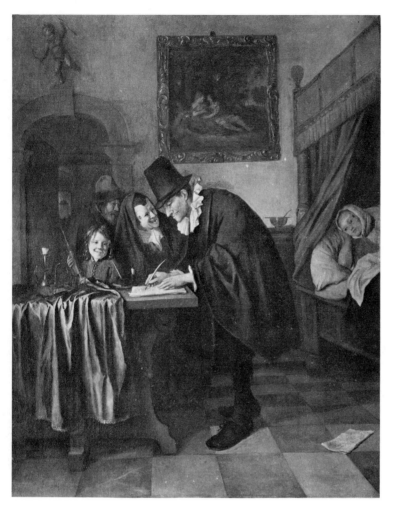

18. *The Doctor's Visit.*
Jan Steen, *c.* 1665

19 *(opposite). The Remedy*
('The Apothecary'). A. Bosse, 1633

the curative clyster, a remedy that has more symbolic than medicinal
value. Another version of the 'Remedy' theme, a print made by
Abraham Bosse in 1633, shows a woman in bed and the doctor with
a clyster accompanied by the lady's maid and, at the far left, another
servant with a *chaise percée* [19]. This print is a document of con-
temporary life and medical practice, but an underlying erotic inti-
mation is revealed by the first lines of the legend inscribed beneath
the image: 'I have the syringe ready; so be quick, Madame, to make

the best of this little libation. It will refresh you, for you are all afire, and the tool that I have will enter gently.'[51] In works like Steen's and Bosse's, however plain the allusions, the women are decently

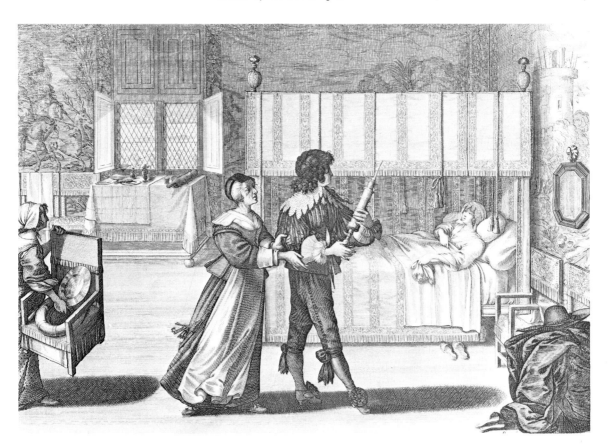

covered and the action is proximate, not immediate. But Watteau recognized and exploited the erotic potential of the subject, and his naked, long-limbed beauty awaiting her cure is the image of voluptuous receptivity.

It is only when one compares *The Morning Toilet* and *The Remedy* with later depictions of the themes that one fully appreciates the unique quality of Watteau's pictures. Boucher, for instance, painted a toilet scene showing a woman attended by her maid. She has

her dress pulled up around her waist, and she faces the spectator while she sits on a bidet. On the floor, as a lewd symbol, a black cat arches its back between the legs of the bidet.[52] This picture, like our illustration 16, was designed to fascinate by shocking our sensibilities and by riveting our attention with a startling disclosure. Many representations are known of the theme of the 'Remedy' which proved very appealing in the eighteenth century.[53] Understandably so, for it affords an unusual opportunity to display special attractions of the female anatomy, and the subject makes an obvious, lewd allusion. In a picture by Jean-Frédéric Schall, one of the last of the eighteenth-century specialists in erotic art, the theme is presented with an almost naïve, novelistic explicitness [20]. The lady has prepared herself on her bed, where she waits with a faint air of blushing expectancy. Her 'officious' maid, about to administer the remedy, makes a silencing gesture as she welcomes a gallant into the room to attend the piquant spectacle.[54] One sees, on the mantel, that Love waits in attendance too, and the painting above, of a couple embracing, reveals what is in everyone's mind. Schall's picture is certainly not without charm, but it is the charm of the erotic peepshow.

All these eighteenth-century works, Watteau's included, offer the spectator the thrill of seeing what is private, intimate, and hence ordinarily forbidden to intruding eyes. However, beside the others, Watteau's pictures seem remarkably restrained in the view they give us. It is this restraint, of course, that has led some critics to underestimate their sensuality and to interpret them as somehow innocent. In fact, they are 'innocent' only insofar as the women represented are neither ashamed of their nakedness nor lewd in displaying it. Watteau's women hide nothing. Yet, while they offer desire its object, they do not flaunt their charms, as women do in Boucher's pictures, and they make no coy disclosures of a breast or thigh, as in works by Pater, for example. Watteau's women take admiration as their due; they do not solicit it. They stir us, seduce us, effortlessly, merely by the aura of their nudity. In his paintings the pictorial emphasis is not on the view of the forbidden object, but on the

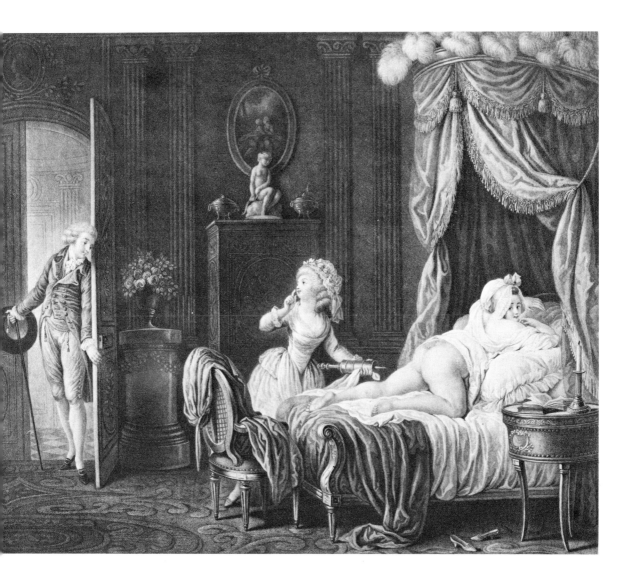

20. *The Remedy*
('The Officious Servant').
Engraving by
A. Chapponier after
J.-F. Schall, 1786

suggestion of erotic *presence*. While other artists titillate the imagination, he arouses the senses and awakens desire. Watteau's approach to his material, by indirection and understatement, lies at the heart of his unique artistic vision, and it explains what would otherwise seem something of a paradox: the latest and most perfect of his erotic pictures is also the least indiscreet in subject matter. The

earlier works, *The Remedy* and *The Morning Toilet*, take up licentious themes which in themselves are meant to pique the beholder's erotic curiosity. Watteau's treatment of them is unusual in that he refuses to underscore their impropriety. The *Lady at her Toilet*, going a step further, is the logical consequence of his approach to *erotica*. Its subject matter is intimate, but, unlike the other erotic pictures, makes in itself no obvious appeal to prurient interest. This observation leads to another: in *The Remedy* and *The Morning Toilet* the nature of the action represented is clear and unequivocal. This is not the case in the *Lady at her Toilet*.

3. The Lady in the Boudoir

A Lady at her Toilet is the traditional title of the Wallace Collection picture. It is a serviceable title, for the woman is engaged in an activity that concerns her personal appearance. However, the name hardly clarifies the action in the picture, and one feels that it was chosen for lack of a more obvious or better one.

A scene of a naked woman holding a chemise while sitting on a bed naturally suggests arising or preparations for sleep, a *lever* or a *coucher*. But which is it? The painter has not made clear whether the room is illuminated by daylight or candlelight; nor has he given us other definite clues to the time of day. This is in striking contrast to most pictures made in the eighteenth century of similar scenes. For instance, a painting by Lavreince of 1776, which is obviously derived from Watteau's work, unequivocally presents a scene of arising, a *lever* [21]: the room is filled with daylight; a candle on the night-table has been snuffed out; the bed has evidently been slept in; and the woman is clearly stepping out of bed as her maid helps her out of her chemise. But Watteau's woman, for all we can tell, could as easily be getting ready to go to bed, like the woman in Baudouin's *Evening* [49], as getting up to a new day. She could as easily be taking off her daytime as her nighttime chemise – or, at either hour, putting one or the other chemise on.

Louis de Fourcaud, who wrote a short essay on Watteau's painting, tried to explain the representation on the assumption that the woman has just bathed and, still naked, has sat down on her bed to put her chemise on before beginning her toilet.[55] Although one might argue that the cloth at the woman's feet is a kind of bath mat, there is no tub or other evidence of a bath to be seen and, therefore, no real support for this interpretation. Furthermore, even if we were to accept the notion that a bath is involved, there is no reason

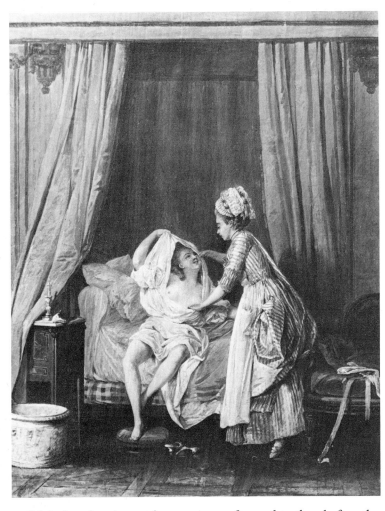

to think that the picture shows a scene after rather than before the bath. Instead of dressing after her ablutions, the woman might be understood to be undressing in preparation for them. This raises the question of whether the chemise is being put on or taken off. Either possibility would be consistent with any suggested interpretations of the general action.

Commentators on the Wallace Collection picture include partisans of both the dressing and undressing theories. The question involved is even more important than that of determining the time

of day of the scene, since the answer given in this instance often colors the interpretation of the picture's expressive character. For instance, an author who believes the woman is taking the chemise off thinks she does so with 'provocative gestures'. Another writer, certain that she is putting the chemise on, explains her gesture as that of a woman 'unexpectedly surprised' who 'hastens to pull the garment down over her'.[56] Signally lacking in the literature, however, are observations that prove one or the other interpretation. All we really see in the picture is a woman who holds the bottom of a chemise open above her head. Whether she is slipping her head into or out of it presents a problem rather like that of deciding whether a picture showing the sun at the horizon shows sunrise or sunset. Some external clue, an indication of compass directions or a suggestion of morning or evening life activities, is needed to decide the question. The only apparent clue to the nature of the scene in the Wallace Collection picture, the action of the lady's maid, is just a shade ambiguous. The maid does seem to be waiting to help her mistress on with the garment she has in her hands. But, while it may seem simplest to assume that the garment is to be put over the chemise the lady holds (and would, therefore, be slipping on), one can also suppose that it is to be held until the lady changes into another chemise, or even that it is to be put over her naked body, to cover her on the way to the bath perhaps.

I believe we must be content to admit that several different explanations of the scene would account about equally well for what is presented to us, and that it is futile to try to identify the action precisely, for the painter has simply not given us enough information. Now when an artist of Watteau's stature allows the spectator a wide latitude of interpretative choices, he does not do so inadvertently. Either he holds exact definition to be of no account, or else he is purposely using ambiguity as an aesthetic device. Purposive ambiguity, however, results not from an absence, but from a multiplicity, of clues to identity. Sometimes in sixteenth-century mannerist art, for instance, expressive intensity is gained from the

co-existence, and hence 'co-perception', of alternative, frequently
contradictory, visual data. This device was almost never, if at all,
used in the eighteenth century,[57] and clearly it does not obtain in
the *Lady at her Toilet*. One must conclude that if Watteau saw no
need to provide specific information that would allow us to identify
the action as dressing or undressing, and the subject as a bath or an
awakening, it is because the picture is not really about a common-
place daily activity. Indeed, it is well to remember that the notion
that genre pictures are necessarily realistic depictions of everyday
life comes from a nineteenth-century misconception of the artistic
mentality of Watteau and his contemporaries.[58]

Indefiniteness of action and locale is a striking trait of many of
Watteau's mature works,[59] whether *fêtes galantes*, theatre scenes,
or paintings of nudes. In *The Remedy* and *The Morning Toilet*,
although the action is clear, there is not, as we have seen, too strong
an expository light on it, and indications of the setting and details of
the scene in those pictures are minimal. In the *Lady at her Toilet*
Watteau went further in the same direction, showing great insouci-
ance about narrative elements, while again giving us no hints about
the room surrounding the immediate locality of the action. There
seems no more point in asking what is on the other side of the curtain
than in trying to find out what the blue garment is that the dog
rumples in his play. One detail in the painting shows Watteau going
beyond indefiniteness to a positive denial of the narrow require-
ments of realistic representation. The 'bed' on which the woman
sits, although related to real bed types of the time, is actually a fanci-
ful construction. Its lower half represents the kind of chaise longue
or *lit-de-repos* that is seen in some of Watteau's drawings [22, 23, 29].
At the top of the bed, the cupid's-head and conch-shell headboard
seems an elaboration of decorative forms that were used on some
real *lits-de-repos*, like the one depicted in illustration 17. But the
combination of the massive, carved and gilded headboard with the
slender forms and elegantly curved legs of the lower half of the bed
would evidently be anomalous in a real piece of furniture.[60] The

invention of this bed for the picture had, as we shall see, formal and iconographic motives. The bed is not so far removed from reality that it disturbs our sense of the plausible. It shows us, however, that for Watteau other purposes took precedence over descriptive accuracy, and that the *Lady at her Toilet* is not meant to be read in terms of realistic documentation of the everyday scene.

Watteau used anecdotal and descriptive materials to provide a convincing setting, an appropriate context, for his subjects; but he placed these materials in the penumbra of vague definition, so that they exist only at the edge of the spectator's awareness. Ordinarily we do not – there is no reason to do so – inquire very closely into them. In the *Lady at her Toilet* we are shown some part of a room, in which a nude woman, holding a chemise over her head, sits on a bed of sorts, flanked by her maid and pet dog. We are told only as much as we need know about these things. One image alone is telling, and it commands the whole of our attention: the woman as she turns to face us. This is the well-spring of the painting's composition, of the shape of its forms, of its color and light. With a cool, untroubled gaze, the woman turns to allow us to look upon her. This unashamed revelation of beauty, so charged with erotic potency, is the true subject of Watteau's painting.

In *The Remedy* and *The Morning Toilet* feminine beauty is also revealed. However, the women in those pictures remain unaware that they are looked upon, and so an appreciable psychological distance separates us from the scene. We become, in a sense, voyeuristic intruders, looking at the women secretly, as though through a peephole. In the *Lady at her Toilet* the woman responds to our presence. The picture creates an imaginative relationship of great intimacy between the woman and the beholder. We stand in the room. The woman shows no surprise, no fear, and no modesty. The maid and the dog take no notice of our presence. We imagine ourselves a familiar of the household who has entered the room during the woman's 'toilet'. The lover is welcome, and the sight of the naked beauty is ours to enjoy.

4. The Lady in the Studio

A drawing by Watteau in the British Museum [29] was the immediate inspiration for the painting of the *Lady at her Toilet*. Several other studies by the master are very closely related to this drawing in style and general character and they show the same model seated or lying on the same chaise longue.[61] All are drawn with red and black chalks, some with the addition of white heightening. These studies were evidently made within a short space of time and it seems possible that they were all actually done in a single drawing session. Taken together they show us something of how Watteau worked from the model and they illuminate the process by which the Wallace Collection picture came into being.

One of the drawings shows the model fully dressed [22]. The woman reclines on the chaise longue, supporting her head with her hand and resting her arm on the wing of the chair; one has the impression that her pose and the fall of her clothing were entirely unpremeditated, the result of her having settled comfortably into the chair. For another study [23] Watteau arranged the model and her costume with some care. She is naked to the waist and lies back in the chair with her arm crooked gracefully over her head and with one hand in her lap. One imagines the artist posing the model, telling her to move her hand up or down or more to the left, suggesting that she move her leg, all the while watching the shifting relationships of forms and waiting for them to fall into a visual pattern that he found harmonious and expressive. At some point during the session the woman sat up and, without dressing or adjusting her clothes, occupied herself with what seems a pedicure [25]. It is impossible to say whether it was at the artist's instructions that she took the pose or whether, during a moment of rest from posing, she

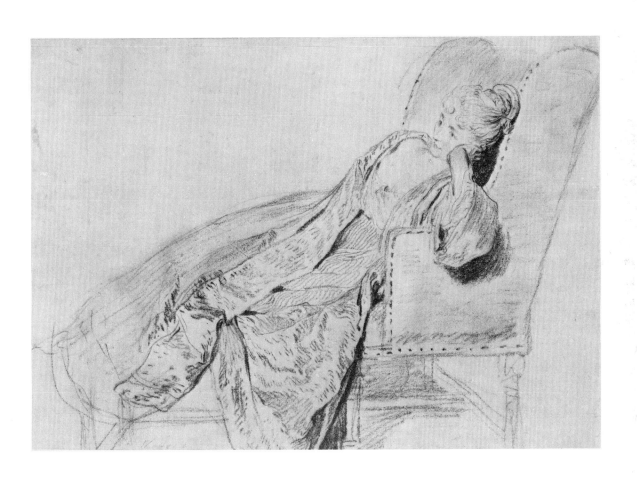

22. *Study of a Woman Reclining on a Chaise Longue.* Watteau, *c.* 1716–17

23. *Study of a Semi-Nude Woman Reclining on a Chaise Longue.* Watteau, *c.* 1716–17

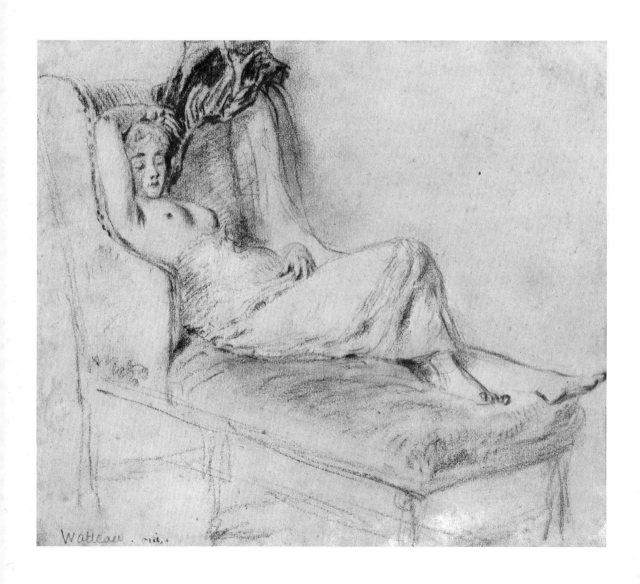

decided to attend to this task. Watteau seems, in any event, to have been struck by the contrast between the unselfconscious activity of the figure and the stately immobility of the chaise longue, and he set the scene on paper.

A detail in this drawing is revealing of Watteau's methods when drawing from life. The chaise longue, obviously a real piece of furniture in the studio, had, as the two sketches already discussed

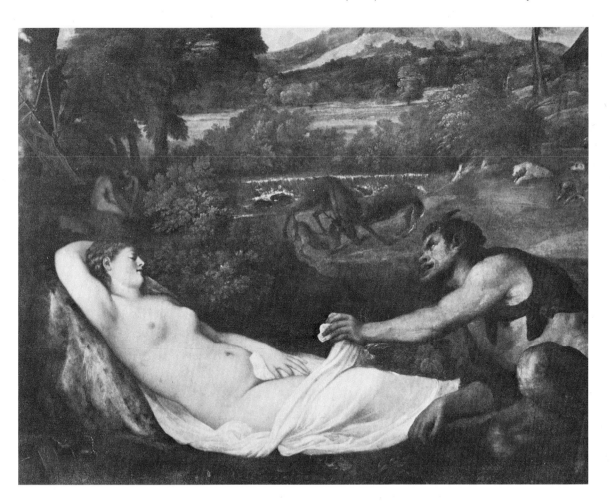

24. Detail of *Pardo Venus*. Titian, before 1567

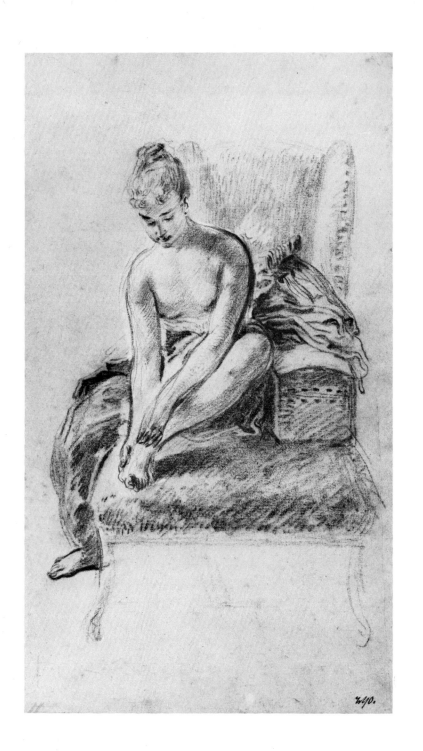

25. *Study of*
a Semi-Nude Woman Seated on
a Chaise Longue.
Watteau, *c.* 1716-17

26 *(opposite). Study of*
a Woman Wearing a Chemise.
Watteau, *c.* 1716-17

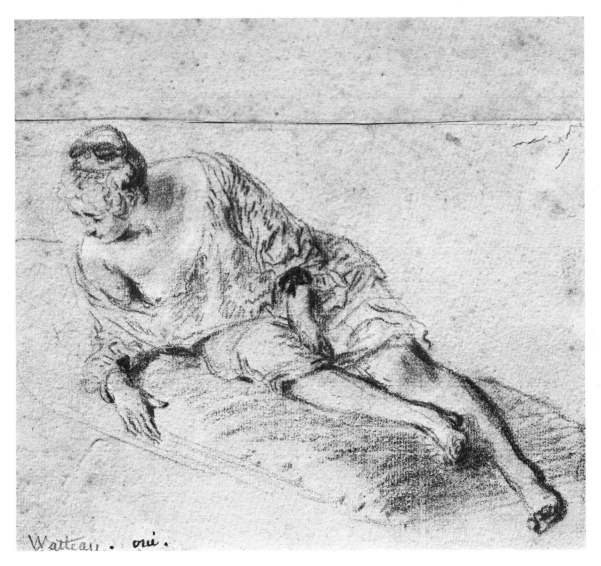

Watteau. oui.

show, three pairs of straight legs, each pair braced near the bottom by a crosswise supporting bar, which in turn was attached to a central support set on the long axis of the chair. In the present drawing Watteau barely noted the lower framework, which in this frontal view would have given the chair an awkward, squat look. Furthermore, instead of straight legs he drew curved ones; they suit the

voluminous flow of forms in the drawing better and they carry the apparent weight resting on them more easily and more gracefully. Watteau seems to have made these changes automatically, disregarding what he saw and knew in order to respond to the demands of the overall design.

In other drawings, surely the most seductive studies in the group, the model is seen clad only in her chemise. The chemise, falling

27. Study of a Woman Wearing a Chemise. Watteau, c. 1716–17

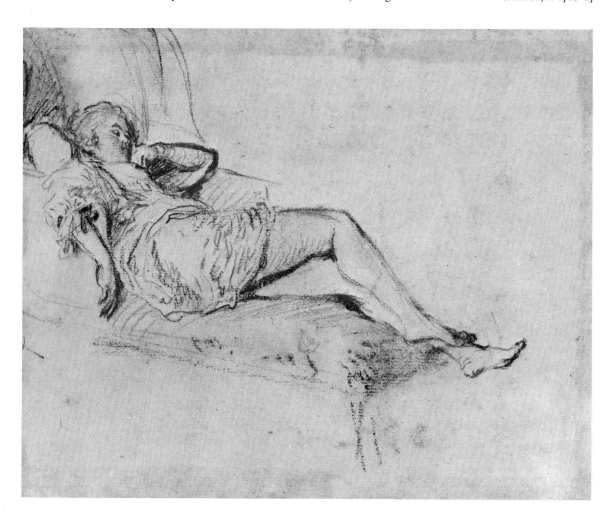

loosely about the female body, slipping off a shoulder, falling open to reveal a breast, riding up on a thigh, veils without concealing and emphasizes the shape it covers. Dressed this way the model appears in poses that have a feline sensuality [26-8]. One feels that the poses were found by allowing the model to luxuriate in her semi-nudity and to settle naturally in positions that were easy and pleasureful. Watteau's drawing companion, Caylus, said that the master was

28. *Study of a Woman Wearing a Chemise.* Watteau, *c.* 1716-17

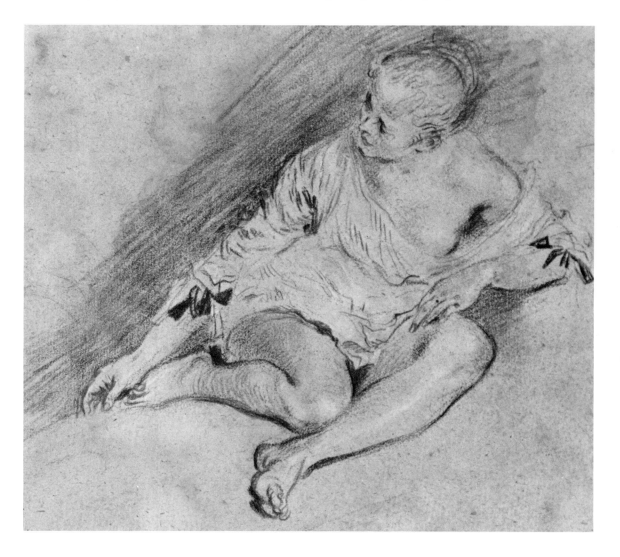

deficient in his knowledge of anatomy and that he could therefore
'neither comprehend nor express' the nude form.[62] This is not a
wholly unfair statement, for the drawings discussed here in no way
measure up to eighteenth-century academic standards for anatomi-
cal rendering. However, the statement is beside the point, because
the drawings do not aim to articulate the structure and mechanics
of bone and muscle, but attempt to capture the voluptuousness of
the female body as it surrenders to relaxation, stretches and turns,
or curls itself up. In achieving this, these sketches are unsurpassed.

Only one drawing in the group shows the model completely nude,
the one that was used for the Wallace Collection picture [29]. For
all the apparent freedom and spontaneity of the pose it is clear,
when one compares it with those of the other drawings, that it is
one of the more deliberate and arranged in the group. It is a pose
that can be held only with some effort on the model's part, and
the composition it creates is too felicitous to have been entirely
accidental. Perhaps Watteau conceived it consciously as a variation
of the poses he had just designed or was still working out for the
Spring of the Crozat 'Seasons'; perhaps it simply suggested itself to
him by chance, by the sight of the model removing (or again putting
on) her chemise. In either event it needed 'artful' adjustments to
bring the figure composition to perfection. Its deliberate character
is fairly clear from the fact that the pose is not an unfamiliar one in
the history of art. One writer has seen in the movement and the
position of the upper part of the body a reflection of ancient statues
of the 'Crouching Venus'.[63] It is improbable that Watteau had such
statues in mind, but closely related poses, ultimately deriving from
antique art, appear in sixteenth- and seventeenth-century works.[64]
However, it would be wrong to suppose that Watteau was deliber-
ately imitating such prototypes when posing the model; instead, as
he moved her about, turned her this way and that, altered the posi-
tion of an arm, he arrived at a pose which had for him a vague famili-
arity and associations – intuitively sensed rather than consciously
recognized – with great art. And because of this it had the ring of

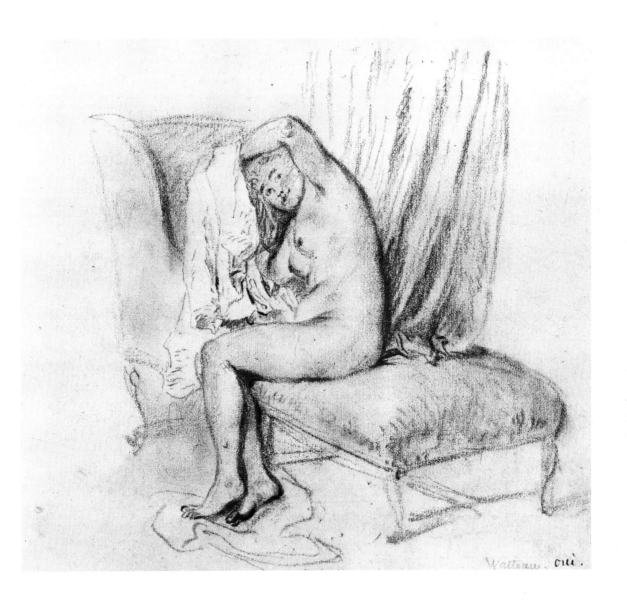

29. *Study of a Nude Woman Seated on a Chaise Longue.* Watteau, *c.* 1716–17

'rightness' and beauty about it. Something similar happened when
he drew the half-nude model reclining with her arm up around her
head [23]; her pose is extremely close to that of Venus in Titian's
Pardo Venus [24], a painting that was in the French Royal Collec-
tion in Watteau's time.

Once he saw the image of the nude in this pose on paper, Watteau
must have been struck by its extraordinary formal coherence and
by its powerful erotic expressiveness. At this point he rapidly
sketched in surrounding details to reinforce the design and to
suggest a whole scene. The curtain, with its repeated pattern of folds
that serves as a foil to the woman's movement, seems to have been
introduced as a compositional device; since there is no sign of it in
any of the related drawings it is unlikely that it was part of the
original studio arrangement. It was also at this time that Watteau
drew in the back of the chaise longue. In other studies he omitted
the chair's back with its large wings, and barely indicated the
cushioned seat on which the model posed [26, 28]. This must have
been true of the first stage of the present drawing too. The back of
the chair, with the exception of the strong accent on the wing, is
drawn more faintly and less decisively than the seat. Furthermore,
the drawing shows a slight misjudgement in perspective, with the
result that the two halves of the chair are not quite properly aligned.
Evidently, they were not visualized and drawn as a single unit.
Initially the chair's supports were accurately, though only partially,
indicated. The underdrawing at the right shows that at first Watteau
drew a straight leg at one end of the chair; as he elaborated and
refined the drawing this seemed unsatisfactory, and he went over
the leg with a heavy black line to give it a curved, cabriole shape
instead. The other legs take the same shape, and they all quietly
echo the woman's movement.

When Watteau decided to use this drawing as the basis for a
painting only a few additions were needed, though they were not
insignificant ones. The maid and dog were added as formal and
iconographic enrichments. The chair was set at a slightly lower

angle to the left and transformed into a 'bed'; the upholstery at its foot was loosened to suggest bedding, and a headboard, rounded to harmonize with the other forms, was invented for it. The woman's pose inevitably dictated the choice of an oval format.

The gradual evolution of the Wallace Collection painting from a study or series of studies made after the model with no ulterior purpose other than the practice and pleasure of drawing is illuminating in both a general and a specific way. In its broader ramifications it helps to clarify Caylus's statement that Watteau 'never made preparatory sketches for any of his paintings'.[65] Though 'never' is of course an exaggeration, the fact is that the vast majority of Watteau's drawings were not made with a predetermined purpose. The paintings, not generally planned in advance, emerged as end products of an organic creative process in which nature was gradually transformed into art.

The genesis of the *Lady at her Toilet* also explains its narrative indistinctness. Unlike *The Remedy* and *The Morning Toilet*, which from the beginning must have been planned as illustrations of specific themes, the Wallace Collection painting was born purely in response to a vision of female beauty. This vision only, not a story or the details of everyday life, inspired Watteau and concerned him during the development of the picture. The setting and event were of minor significance and required no precise definition.

5. The Lady as Woman of Pleasure

In discussing *The Morning Toilet* and *The Remedy* we found that nudity in genre pictures was considered rather daring in Watteau's time. Those paintings were daring and they derived from pictorial traditions of dubious propriety. The *Lady at her Toilet* had an innocent beginning in sketches of the model, and it makes, certainly, a less obvious appeal to prurient interest than do Watteau's earlier erotic works. Yet there remains the matter of nudity. In the early eighteenth century women out of classical mythology or Bible stories – Venuses or Bathshebas, for instance – were expected to be seen at their toilets in the nude. But ordinary women, unless they were telling us about the vanity of earthly beauty or serving some other allegorical or symbolic purpose,[66] were not supposed to be seen, in 'proper' pictures, without their clothes. Women who do appear nude in genre paintings often represent prostitutes; for the virtuous spectator the mere sight of a bejeweled, buxom wench who reveals her breasts as she combs her hair [30][67] carried the message that concern for the seductive allures of the flesh is meretricious and sinful. Naturally, not all spectators could be depended upon to receive the message clearly.

There is good reason to interpret Watteau's 'lady' in the Wallace Collection picture as a courtesan, although, as we shall see, only with important qualifications. Toilet scenes in general have as an underlying theme the beauty and seductiveness of women, and grooming was, of course, for the most part seen as being motivated by vanity. When taken out of the realm of story or elaborate allegory, the toilet scene, even when the woman is dressed, immediately acquires an all too worldly air, as the representation of an activity more typical of the brothel than of the righteous household. This

30. *A Courtesan at her Toilet.*
C. van Everdingen,
mid seventeenth century

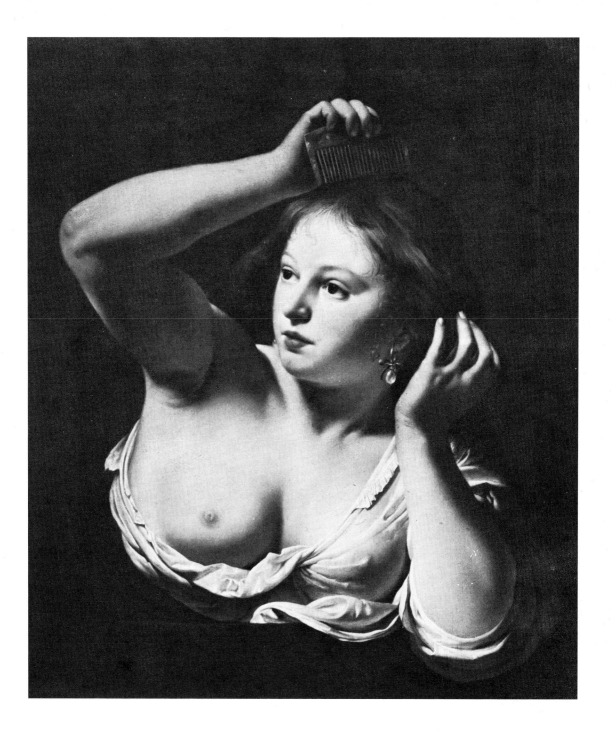

naturally changed in the course of the eighteenth century, when the lady's 'toilet' became a very important and even a stylized part of personal and social life. Earlier, however, especially in Holland where Protestant morality militated very strongly against personal vanity and display, toilet scenes often contain suggestions of something other than an ordinary domestic event.[68] Frequently, a brothel setting is made quite specific. Michael Sweerts, for example, painted a woman grooming herself with the help of a maid [31]. The woman's

31. *A Courtesan at her Toilet.*
Michael Sweerts, *c.* 1645

finery and the appearance of a client entering the room through a door at the rear clearly situate the scene in a brothel. The mirror the woman holds is a common symbol of vanity and of lust.[69] The spectator is thus given a hint; he is expected to respond to the temptations of the flesh through his awareness of the insubstantiality and transience of earthly delights. Equally plain in character is Jan Steen's *Morning Toilet* [32], where a woman pulls a stocking over her naked leg as she looks out at the spectator through an entryway

32. *The Morning Toilet.* Jan Steen, 1663

33. *Nude Woman with Cupid*. N. Knupfer, mid seventeenth century

crowned by a cupid's head. The rumpled bed she sits on and on which a dog lies, and the open jewel-box on the table beside her leave no doubt about the nature of the woman and her invitation. Steen has placed a book of music, a skull and a lute – symbols of lust, death and transience – on the threshold of the room to spell out the picture's message.

Watteau's painting shares several elements with Steen's work: the bed, the act of dressing, the cupid's head and the dog. Also, like the pictures by both Steen and Sweerts, it shows the woman looking directly at us, inviting and welcoming. This direct gaze at the spectator is typical of brothel scenes and representations of courtesans [34].

In a painting by Nicolas Knupfer [33], dating from the mid seventeenth century, it is not the whore, but the woman in the background, the procuress, who looks out at us. This picture is specially relevant in our discussion because of its obvious similarities with Watteau's painting. It is precisely the kind of image Watteau's contemporaries would have thought of when looking at the Wallace Collection picture.[70] It has been shown that Knupfer's painting derives from Italian Renaissance depictions of Venus and Cupid, and perhaps specifically from a type showing Venus anxiously awaiting the arrival of her lover, Mars.[71] However, the image has been transposed into a scene of contemporary life, and it is not the goddess of Love, but one of her mundane devotees who waits lying on the bed, naked but for a necklace of pearls and pendant earrings. In Knupfer's painting the winged cupid who sits on the woman's thigh, with his foot suggestively placed, clarifies the theme of the nude awaiting to perform in the service of Venus.

Watteau, too, while showing a scene of contemporary life, tells us with an emblematic reference, similar to the cupid's head that appears over the arch in Steen's painting [32],[72] that his nude woman waits for us under the sign of Love. It is an indication of the extent to which some critics have been unwilling to recognize intentional erotic content in Watteau's works that Louis de Fourcaud

described the bed in the Wallace Collection picture as being topped
by a 'chimerical head'.[73] The headboard is, of course, composed of
a shell, emblem of Venus, and topped by a cupid's head. Watteau
had employed the same idea earlier, in a rather schematic way, in
The Morning Toilet [11], where Cupid's quiver is prominently
featured on the headboard. More forcefully now, the gilded cupid
and shell make a radiant allusion to the fabled toilet of the goddess
of beauty and they transform the bed into a throne of love.[74]

Other details in Watteau's painting reinforce its connexion to
courtesan and Venus imagery. The chemise the woman holds of
course serves to heighten the suggestiveness of the picture, since
the presence of what the woman is not wearing makes us more aware
of her nudity. However, the chemise also has specific associations
with the bestowal of sexual favors. In paintings of courtesans a semi-
transparent chemise worn so that one breast is bared is a standard
item of costume [30],[75] and a rather crude 'popular' print [34] quite
strikingly demonstrates the connexion between Watteau's woman
holding a chemise over her naked body and depictions of prostitutes
in brothel scenes. It is interesting that in Crozat's collection there

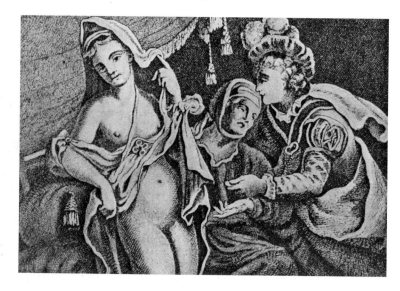

34. *Brothel Scene.*
Anonymous Dutch engraver,
early seventeenth century

35 (*right*). Study for a
Toilet of Venus.
Guercino, *c.* 1625

36 (*below*). Detail of
The Judgement of Paris.
Watteau, *c.* 1720

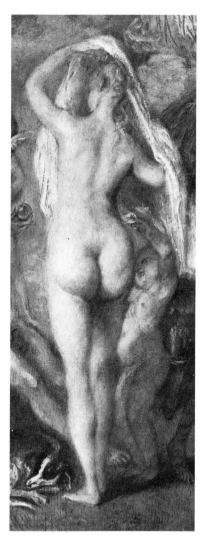

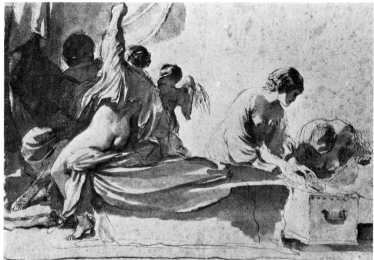

was a now lost painting, variously attributed to Tintoretto or Veronese, that was described as a 'woman putting on her chemise'.[76] One wonders what its real subject was. It seems possible that it was a toilet of the goddess of Love herself. Indeed, an enchanting drawing by Guercino shows a toilet of Venus in which Cupid and one of the Graces help Venus on with her chemise [35].[77] When Watteau

represented Venus in his *Judgement of Paris* he showed the goddess aided by Cupid, lifting her chemise over her head to display herself to Paris [36].

In a peripheral way the maid may also be understood as contributing to the courtesan theme. At least, a maid is often seen in brothel scenes assisting the courtesan to arrange her hair or attire [31], and sometimes she plays the part of procuress [34]. In eighteenth-century French pictures of the life of gallant, but polite, society, it is not unusual to find the lady's maid acting as the intermediary between the woman and her admirer [20]. However, this association provides at most no more than a pale connotative tint to Watteau's picture, where the maid is so passive that we are tempted

to regard her as a wholly impersonal part of the scene. Indeed, people in the eighteenth century seem to have regarded their servants in this way. Madame de Pompadour, for instance, is reported to have explained to her maid that her presence when Louis XV visited was no inconvenience. 'The king and I', said Pompadour, 'think of you as a cat or a dog, and we just go right on talking.'[78] The maid in Watteau's picture actually may be more innocent of meaning than the dog, a symbol of carnality, which will be discussed in the next chapter.

Despite its intimate relationship in general type and in specific motifs to traditional courtesan images, the Wallace Collection picture differs from them in a fundamental way. Watteau's woman, unlike the courtesans in the other paintings we have discussed, does not solicit, and she neither wears jewelry nor has any near her. In other words, her action and appearance do not suggest an illicit proposal or venal interest. She seems to offer herself freely, with a joyousness that wholly excludes sinful or sordid motives.

The artists who created the pictures with which I have compared Watteau's painting all began, no doubt, with the idea of representing a courtesan or brothel scene, and from the beginning they must have conceived the meaning of their pictures as didactic or moralizing.[79] Not all the artists expressed this meaning as overtly as Steen did, but all provided sufficient clues for the spectator to understand the message. Knupfer shows a familiar household vessel overturned beside the bed [33] to indicate the foulness and impurity of venal love. But Watteau hints at nothing of the kind.

Watteau did not begin his picture with the idea of representing a courtesan. He began with a life study, a voluptuous image of feminine beauty in a pose of wonderful receptivity [29]. In elaborating it into a finished picture he intuitively drew on a pictorial type that expressed seductivity and sexual offering, and his painting acquired, through its association with that type, a heightened eroticism. The kind of courtesan or brothel scene that Watteau adapted was traditionally given a context framed to deny the appeal

of its erotic subject matter. Watteau ignored this context. The new possibilities for erotic art that were developing around 1700, and which also help to explain the creation of works like *The Morning Toilet* and *The Remedy*, freed him from the need to justify his painting with a moralizing statement. The 'lady' in the Wallace Collection picture must inevitably have suggested a courtesan to Watteau and his contemporaries. But now no guilt was attached to the imaginative acceptance of her offering. There is only the promise of love and pleasure. It is as if Watteau had reached behind the façade of Christian morality that artists like Knupfer had erected in front of images derived from illustrations of classical mythology. The woman in Watteau's painting welcomes the spectator in the spirit of Titian's Danaë receiving her lover, Jupiter [10].

6. The Lady and her Dog

There has surely never been a time in the history of civilization when dogs were not kept as pets. Naturally, therefore, they appear frequently in art, often for no other reason than that they are part of the 'human' scene. Still, man's attitude toward dogs has varied, and a 'dog's life' has been different things at different times. The eighteenth century in France was a kind of golden age for dogs, or at least for ladies' lap-dogs. They were cherished and pampered to the point of absurdity. One lady, Madame Helvétius, dressed her pets in silk, and fed them from gold plates. A lap-dog was a lady's most faithful companion, sharing her bed, awakening her (like Belinda's 'Shock' in Pope's *The Rape of the Lock*, 'who thought she slept too long, Leap'd up, and wak'd his Mistress with his tongue'), and following her through the activities of the day.[80]

The faithful dog, best friend to man, is a notion of great antiquity. In art the dog often denotes Fidelity; everyone is familiar with medieval and Renaissance tomb sculptures where a dog, sometimes two, sits at the feet of the effigy of his dead mistress, thus symbolizing her possession of the wifely virtue most highly prized by husbands (whose own effigies were generally footnoted, as it were, by brave and bold lions). The deliciously shaggy dog in Jan van Eyck's famous wedding portrait of the Arnolfini couple in the National Gallery, London, symbolizes the vow of fidelity that the marriage bond requires. The spaniel that appears in Fragonard's painting of *Love and Friendship* [37] is just one of countless examples of the same iconographic usage in the eighteenth century.[81]

The idea that the dog is a dirty cur seems to have arisen in the Middle East, and it captured the fancy of some Biblical personages and authors. Matthew reports Christ's injunction: 'Give not that

37. Detail of *Love and Friendship*. J.-H. Fragonard, 1771–3.

38. *Courtesans on a Balcony.*
Carpaccio, *c.* 1490

which is holy unto the dogs' [vii, 6]; and to St John on Patmos it was
revealed that 'without [the city of God] *are* dogs, and sorcerers, and
whoremongers' (Revelation xxii, 15). By its association with evil
and unclean things the dog was inevitably identified with sexuality

and the carnal appetite. The history of art abounds in pictures where the dog symbolizes lust or animal passion. Paintings of Venus reclining in enticing nudity, by Titian, for instance, often include a small dog; even in modern times we find Cézanne, for example, using a dog to symbolize carnality.[82] It is not surprising that lapdogs have been among the traditional pets kept by courtesans;[83] the woman in Jan Steen's *Morning Toilet* [32] has her pet spaniel beside her on the bed. In Carpaccio's well-known painting in the Correr Museum in Venice, which is generally thought to portray two prostitutes,[84] one of the women holds a small dog fast by its front paws while teasing another dog [38]. The allusion in this picture to the woman's aggressive sexual incitement and domination of the male is plain, and it reappears, though in a much more polite

39. Detail of *Fête in a Park*. Watteau, *c.* 1718

and charming form, in Watteau's *Fête in a Park* in the Wallace Collection. There, in the left foreground, two little girls try to make a dog play with them [39]. The dog is on a lead and one girl tugs hard at it. The animal is forced at least to turn its head. This scene

40. Detail of *Fête in a Park*.
Watteau, *c.* 1718

serves to clarify the action on the other side of the picture, where three flirtatious young women try to arouse the interest of three gallants [40].

There is no necessary contradiction in the concept of the dog as a faithful companion and also as a lascivious creature. Probably it corresponds rather closely to some conceptions of the ideal lover. In many pictures the dog does, in fact, symbolize the lover. A French eighteenth-century print after a painting by the seventeenth-century Dutch artist Frans van Mieris I, shows a bedroom where, while a maid makes the bed, a dog does his tricks for his mistress [41]. The print is supplied with a poem which interprets the dog as a representation of the 'manageable lover' or 'foolish husband' who 'dances' at the woman's command.[85] It is also the dog as lover who appears in an eighteenth-century French toilet scene by Regnault [42]. Here, however, the statement is not couched in allegorical terms. In the scene of the dog rising straight up from the chair to paw at his mistress, who pauses as she undresses to stroke the animal, the artist uses highly suggestive visual metaphors.

We may mention in passing that dogs in French eighteenth-century pictures are sometimes more than symbolic surrogates for the human lover. The dog as a real sexual partner is a fairly familiar

theme in erotic literature. In Diderot's tale of the cocker spaniels in *Les bijoux indiscrets*, young Sindor finds it impossible to dislodge his lady's jealous pets from her affections. Although the history of sexual practices is not our concern, it is revealing of the moral licence characteristic of the eighteenth century in France that the use of small dogs for lascivious purposes apparently became something of a fad during the period. Contemporary pictorial representations

41. *The Dutch Awakening.* Engraving by F. Basan after F. van Mieris I, third quarter of the eighteenth century

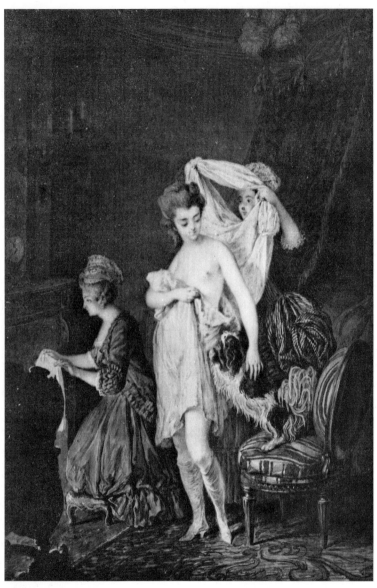

that quite openly allude to the practice are surprisingly numerous.
The best known work of this kind is Fragonard's picture of a naked
girl in bed offering a symbolic ring-biscuit to an eager little dog [43].
During the French Revolution some dogs like these were condemned
to be burned in the Place des Grèves.[86]

This short survey of canine iconography has led far beyond the range of meanings intended by Watteau in the Wallace Collection picture. However, our discussion will have shown that the dog in Watteau's painting would have suggested more than a household pet to the eighteenth-century spectator. The spaniel's presence

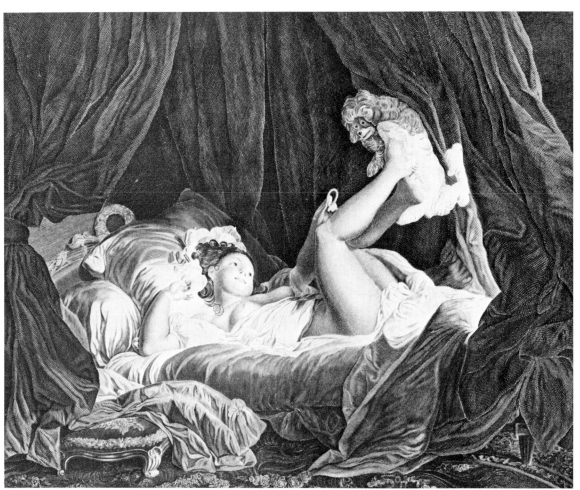

serves to enrich and comment upon the theme of the picture. By its inherently erotic associations the dog contributes to the pervasive sensuality of the scene; by its action it mimes the response of the spectator-lover, who must also look with mounting excitement upon the splendid nudity of the woman.

Conclusion

In this study of the *Lady at her Toilet* I have tried to show its debt to an earlier Netherlandish tradition of genre scenes. Its general type and specific motifs reflect such works as Jan Steen's *Morning Toilet* [32] and Knupfer's *Nude Woman with Cupid* [33]. Yet, in a most important way, Watteau's painting is unlike such prototypes. Its mode of visualization is quite different.

In typical Netherlandish genre scenes showing interiors [32, 50] the figures are almost always relatively small in relation to the setting. Furthermore, the place where the action occurs is usually defined in a way that lets us guess the general shape and size of the room even when it is only partly visible in the picture. The way the light enters the room often tells us where the window is placed and, for that matter, the time of day. Precise rendering is also used to describe costume and furniture. The result is that these Netherlandish paintings have a literal, documentary appearance. This way of representing places and things was taken over from the Netherlanders by the French artists of the seventeenth century who made pictures of contemporary fashions and manners [17], which, of course, also had their influence on Watteau. However, the pictorial characteristics typical of these traditions are entirely absent from the Wallace Collection painting.

In the *Lady at her Toilet* the setting and its component details are given only a vague definition. The human form wholly dominates the scene, and not only by virtue of its large size in relation to its surroundings. The very shape of the picture, the quality and movement of its color and light, the design of its individual elements and the compositional rhythms that connect them, have been determined by the expressive character of the figure's form and pose. The figure

is the basis of an ideal harmony of visual relationships. The source of this mode of picture-making is the Grand Manner that was created during the Italian Renaissance and that Watteau learned to love in the works of such artists as Titian, Veronese and Rubens.

The Wallace Collection picture was painted towards the end of a decisive period in Watteau's career. When Watteau entered this period his art still displayed his primary dependence on currents that derived largely from earlier Netherlandish genre painting. The *Lady at her Toilet* owes its 'domestic' character to this fact, while its origin, in drawings made of the live model, shows the artist's attachment to the Netherlandish tradition of fidelity to observed nature. It is interesting to compare a life study by Watteau [44] with the woman in Steen's *Morning Toilet* [45]. There is surely no direct connexion between the two works, but the comparison offers telling testimony

44 (*left*). Detail of *Studies of a Woman*. Watteau, *c.* 1715

45 (*below*). Detail of 32

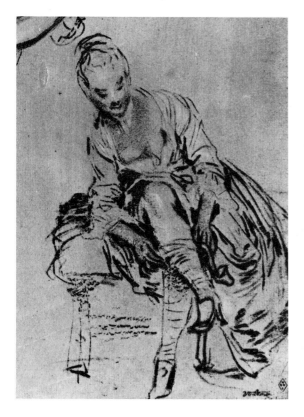

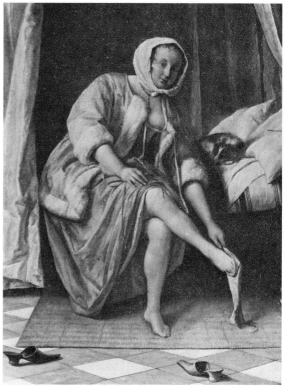

that Watteau, at one level of his creative imagination, shared the artistic ideals of painters like Steen. During the period when he studied Crozat's collection of paintings and drawings, and when he worked on the 'Seasons' commission, Watteau's art matured. The form it took by the time he painted the Wallace Collection picture is explained by those experiences. From then on all his works – the *Pilgrimage to Cythera* and *Gersaint's Signboard* as much as the *Lady at her Toilet* – were indebted to the artistic modalities of the Grand Manner. But this fact is perhaps most immediately visible in the *Lady at her Toilet*, where Netherlandish brothel iconography and description of everyday reality have been transformed by reference to the sensuous pagan imagery and grand formal artifice of works like Titian's *Danaë* [10].

The Wallace Collection picture also helps to shed light on the nature of Watteau's importance for artists who came after him. The *Lady at her Toilet* is usually understood as standing at the beginning of the French eighteenth-century tradition of erotic domestic scenes.[87] In point of time this is obviously true. But the question is whether Watteau's painting inspired the tradition. To suppose that it did so is also to suppose that the picture itself exerted a considerable degree of influence, and this is very difficult to prove. In part, the problem is that we do not know where the painting was during the eighteenth century. This, and the fact that only one copy is known and that no print was made after it, means that we cannot easily assess probabilities when we examine later works and attempt to distinguish between fortuitous visual parallels and direct reflections of Watteau's painting.

Pictures showing indisputable evidence that they derive from the *Lady at her Toilet* are extremely rare. One example is a scene of women bathing [46] painted by Watteau's friend and close follower, Lancret, in the 1720s. The main group of the woman and her maid were plainly taken over from Watteau, though Lancret reversed the direction of the woman's pose and, one might note, allowed her voluptuous gesture to degenerate into piquant attitude. A picture

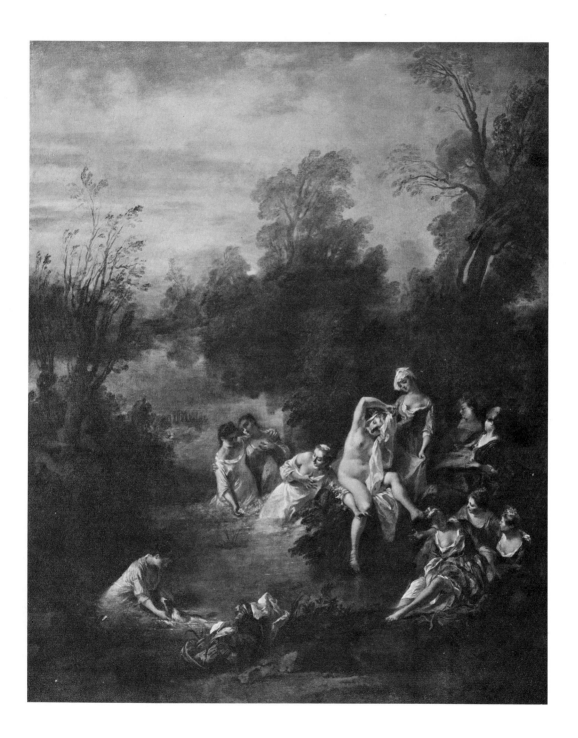

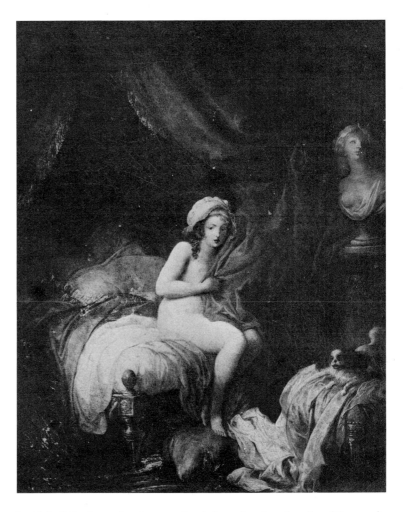

46 (*opposite*). *Summer.*
N. Lancret, *c.* 1725

47. *The Charming Hiding-Place.*
J.-F. Schall, *c.* 1783

by Schall [47], made about 1783, is less clearly related to Watteau's painting. It contains no specific quotation from the Wallace Collection picture and its theme is a different one. Schall's nude is a virginal girl who attempts to cover herself, and his dog is a faithful protector that challenges the spectator. Yet it is hard to imagine that the compositional scheme of this picture, its intimate bedroom setting, and the motifs of the excited dog and the girl engaging the spectator directly were invented without knowledge of Watteau's painting.[88]

We are on still less certain ground when confronted by toilet scenes like one by Lavreince [48] dating from about 1780. Another painting [21] by this artist shows that he must have known the Wallace Collection picture, and this one contains the same pictorial

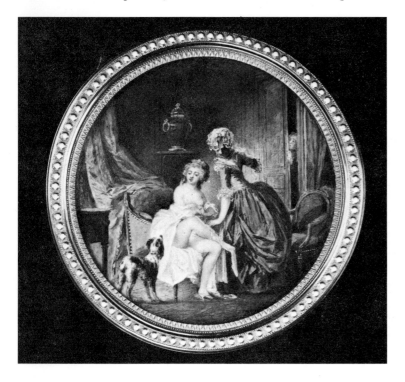

48. *The Toilet Interrupted.*
N. Lavreince, *c.* 1780

49 (*opposite left*). *Evening.*
Engraving by E. Ghendt
after P.-A. Baudouin,
mid eighteenth century

50. *The Interruption.*
G. Metsu, *c.* 1660

elements and even Watteau's dramatic idea of the toilet interrupted (by a spectator now *in* the picture). Still, there is reason to doubt that Lavreince's charming picture was directly inspired by Watteau's work. The toilet scene and its details could have come from sources other than Watteau and, as Lavreince depicts it, the scene differs in fundamental ways from the *Lady at her Toilet*. The action and the setting are presented in an illustrative, anecdotal fashion, and are precisely, even meticulously, defined. Just these characteristics of seventeenth-century Netherlandish and French domestic scenes were rejected by Watteau. But they are typical, not only of Lavreince's works, but of most erotic genre paintings made in France in the

eighteenth century, which seem, therefore, not to have been significantly affected by Watteau's work. A picture entitled *Evening* [49], by Boucher's son-in-law, Baudouin, for example, can be explained without any reference to Watteau; in subject and presentation it

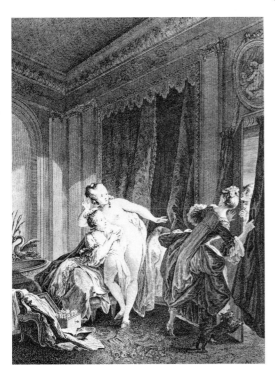 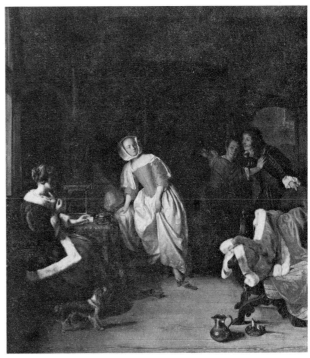

is, in fact, just an up-dated, more titillating version of seventeenth-century paintings like Metsu's *The Interruption* [50].

The psychological intensity of Watteau's *Lady at her Toilet* and the grandeur of its formal conception are qualities that link it and its creator to the mentality of the *Grand Siècle*, and that separate them from the novelistic and picturesque imagination of the age of Louis XV. It is significant that the few eighteenth-century pictures that suggest an essential connexion with the Wallace Collection painting (in contrast to the mere borrowing of motifs from it), were made by artists whose work foreshadows early nineteenth-century painting. Schall's *Charming Hiding-Place* [47], prettily sentimental

in its presentation of the naked charms of a timid, innocent beauty, shows some appreciation of the psychological force of Watteau's picture. Fragonard's *Stolen Shift* [51] seems a conscious variation and amplification of the conceit of the Wallace Collection painting. A new note is introduced by a more overt use of symbol and visual metaphor, and an image of inflamed desire replaces Watteau's

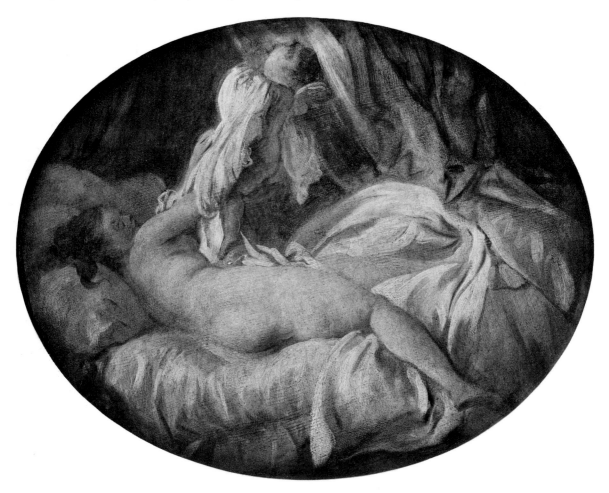

vision of sensual responsiveness. But, as in the *Lady at her Toilet*, it is the expressive power of the human form that dominates Fragonard's picture and that communicates its meaning.

The French Revolution and its aftermath momentarily obscured what artists had achieved during the *ancien régime*. By the 1830s, however, Watteau and his successors were being rediscovered.[89] Again, we are hindered in the search for the influence of the *Lady at her Toilet* by our ignorance of the picture's whereabouts before the late nineteenth century. Can it be that Manet, for instance, knew it,

51 (*opposite*). *The Stolen Shift.* J.-H. Fragonard, *c.* 1765

52. *Study for a Toilet Scene.* Manet, *c.* 1862

and that it suggested one of his drawings of a toilet scene [52]? If so, Manet concerned himself only with the surface appearance of Watteau's masterpiece. The deeper, sensuous spirit of the Wallace Collection picture was inaccessible or uninspiring to those nineteenth-century artists who adhered to aesthetic ideas that called for dispassionate, objective renderings of visual phenomena. Other artists – Delacroix and his Romantic colleagues[90] early in the century, and Renoir later on – would surely have been more responsive to the voluptuous content of the picture had they known it.[91] However, the *Lady at her Toilet* seems to have had no real influence in the nineteenth century. But, as we have seen, it was not influential even in its own century. In a certain sense this was true of all Watteau's works. The common notion that developments in eighteenth-century French painting were founded on Watteau's inventions is based on a misleading oversimplification of the master's historic role. By his innovations Watteau truly revolutionized the possibilities of artistic vision and expression; however, the great painters who came after him – Boucher, Chardin, Fragonard – though not without specific debts to him, formulated those possibilities in ways that were not essentially his. The *Lady at her Toilet*, like Watteau's other works, belonged to a world of history and imagination that passed quickly and that could not be revived. But its image remains for us, inviting and vibrant.

Notes

I wish to acknowledge my debt to Kathleen Weil-Garris Posner who, while this essay was being written, made most helpful suggestions about matters of content, and who generously laboured over the final manuscript in an effort to make it readable.

1. *French Painting of the XVIIIth Century*, London, 1899, p. 86.

2. *Catalogue . . . de l'oeuvre d'Antoine Watteau*, Paris, 1875, pp. 171f.

3. The assumption that this was the picture attributed to Watteau sold in 1777 by the Prince de Conti is based on H. Mireur's reference in his *Dictionnaire des ventes d'art* (Paris, 1912, VII, p. 473) to '*Une femme assise sortant du bain*'. The citation is incomplete. The Conti sales catalogue (Paris, 1777, p. 205, no. 667) continues: '*du paysage, des fabriques, & un jet d'eau servent de fond à ce tableau.*' (The dimensions given for the painting, on canvas, equal 54.1 x 43.3 cm.) The '*Intérieur, jeune femme sortant du bain*' and '*la Toilette*' in the sale of Mme Benech (Paris, 7 March 1828, nos. 22, 23, as Watteau) have sometimes been identified with the Wallace Collection painting and sometimes with *The Morning Toilet* [11]. But in the absence of descriptions or dimensions of Mme Benech's paintings such identifications remain speculative. (Cf. E. Dacier and A. Vuaflart, *Jean de Jullienne et les graveurs de Watteau au XVIIIe siècle*, Paris, 1922–29 [henceforth cited as D-V], III, p. 128, no. 306.) In 1835 a '*Toilette*' attributed to Watteau and owned by Henry Broadwood was shown at the British Institution Exhibition in London (catalogue, p. 13, no. 128), but no information that would identify it further was given. (This '*Toilette*' was not included in the Broadwood sale of 25 March 1899 at Christie's.) It is not known how long the present painting was in the possession of the Marquis Maison. Apparently, he owned it in 1867 (cf. H. Adhémar, *Watteau*, Paris, 1950 [henceforth cited as Adhémar], p. 229, no. 200). It was sold as lot 8 (entitled '*La Toilette*') to Richard Wallace for 13,000 francs in the Maison Sale on 11–12 June 1869 at the Hôtel Drouot, Paris.

4. The copy (rectangular format, 92 x 72 cm.) in the museum of Valenciennes has as pendant a copy of *The Morning Toilet* [11], the latter reversed and so evidently made after Mercier's print (see below, n. 33).

The pair was confiscated by the revolutionary government from the collection of the Comte de Lamarch at Raismes. (For this information I am grateful to M. André Hardi, Conservateur of the Valenciennes museum, who also made it possible for me to study the paintings.) These very clumsy pictures are traditionally attributed to Watteau's friend Nicolas Vleughels, the first reference to them under that name appearing in Dr Lachaise, *Manuel pratique et raisonné de l'amateur de tableaux*, Paris, 1866, p. 132. However, the attribution was rightly rejected in T. Demmler, A. Feulner, and H. Burg, *Kunstwerke aus dem Besetzten Nordfrankreich ausgestellt im Museum zu Valenciennes*, Munich, 1918, p. 76, nos. 383-4, and in Thieme-Becker, *Künstlerlexikon*, Leipzig, 1940, XXXVI, p. 461, s.v. '*Vleughels*'.

5. E. H. Zimmermann, *Watteau* (Klassiker der Kunst), Stuttgart-Leipzig, 1912, pl. 50: 1716-18; J. Mathey, *Antoine Watteau; Peintures réapparues*, Paris, 1959, p. 69, and E. Camesasca, *Watteau* (Les Classiques de l'art), Paris, 1970, p. 115, no. 175: around 1717; Adhémar p. 229, no. 200: 1719; A. Brookner, *Watteau*, Feltham, 1967, p. 39: 1720. Adhémar has more recently ('*Watteau et ses amis*', *L'Oeil*, no. 14, February 1956, p. 22) attempted to support her dating by suggesting a relationship between the painting and a study by Watteau in the British Museum (K. T. Parker and J. Mathey, *Antoine Watteau; Catalogue complet de son oeuvre dessiné*, 2 vols., Paris, 1957-8 [henceforth cited as P-M], no. 785) of a maid that is drawn on paper having a watermark of the arms of the City of London, and therefore almost certainly made by Watteau during his stay in London. Aside from the very general similarity of the costume of the maids in the two works there is nothing in my opinion that specially connects them.

It should be noted that whatever date is given to the Wallace Collection picture, it is generally placed several years later than the Crozat 'Seasons'. Exceptionally, A. E. Brinkmann (*J. A. Watteau*, Vienna, 1943, p. 21) believed it contemporary with the 'Seasons' and related the drawing of Flora [8] to it.

6. Even when, as in the case of the Metropolitan Museum's *Mezzetin*, it is obvious that Watteau himself finished the picture as a rectangle, it is not certain what he finally decided about framing. The *Mezzetin*, possibly acquired by Watteau's friend Jean de Jullienne during the artist's lifetime, was apparently framed as an oval in Jullienne's collection. (See C. Sterling, *A Catalogue of French Paintings XV-XVIII Centuries* [Metropolitan Museum of Art], Cambridge [Mass.], 1955, p. 106.) Only

recently has it been shown that the *Rendez-Vous* was really painted by Watteau as an oval rather than as a rectangle. (See M. P. Eidelberg, 'Watteau's "Le Rendez-Vous"', *Gazette des Beaux-Arts*, LXX, 1967, pp. 288ff.) Eighteenth-century amateurs seem not to have been especially sensitive to the question of format. The *Rendez-Vous* and the Chantilly *Cupid Disarmed by Venus* [7], for instance, both oval pictures, were engraved as rectangles in the 1720s (D-V, IV, nos. 87, 174).

7. I am grateful to Mr Francis Watson, Director of the Wallace Collection, for this information and for giving me the opportunity to study the painting out of its frame. No one in recent years has, to my knowledge, suggested that the picture was not originally an oval.

8. See E. H. Gombrich, 'Raphael's *Madonna della Sedia*', in his *Norm and Form*, London, 1966, pp. 64ff.; also M. Hauptmann, *Der Tondo*, Frankfurt, 1936.

9. Before the painting was destroyed by fire in 1966 (cf. 'Chronique', *Gazette des Beaux-Arts*, LXVIII, October, 1966, p. 23) it was published by M. Levey, 'A Watteau Rediscovered: "*Le Printemps*" for Crozat', *Burlington Magazine*, CVI, 1964, pp. 53ff.

10. Cf. Levey, ibid., pp. 57f. For Crozat's letter to Rosalba, see V. Malamani in *Le Gallerie Nazionali Italiane*, IV, 1899, p. 109.

11. P-M, I, pp. 71f.

12. For this painting, now lost, see D-V, III, p. 63, no. 127; for the closely related *Partie Quarrée* see J. Cailleux, 'A Rediscovered Painting by Watteau: "La Partie Quarrée"', *Burlington Magazine*, CIV, 1962, April advertisement supplement.

13. It had been in France since 1633. It is not known exactly when Crozat bought it, but it was the most highly prized painting in his collection. See M. Stuffmann, '*Les tableaux de la collection de Pierre Crozat*', *Gazette des Beaux-Arts*, LXXII, 1968, p. 76, no. 156.

14. Brief color notes are given by Levey, op. cit., pp. 53ff. Coloristically, the painting must have been very like the Washington National Gallery's *Summer* (illustrated in color in Brookner, op. cit., pl. 11).

15. Contemporaries apparently considered Watteau a Fleming. Count Tessin in 1715 referred to him as a Fleming (C. Nordenfalk, *Antoine Watteau och andra franska sjuttonhundratalsmästare i Nationalmuseum*, Stockholm, 1953, pp. 64, 146, n. 6, 153), and Jullienne called him '*peintre flamand*' (D-V, II, p. 40).

16. For Crozat and his collection, see Stuffmann, op. cit.

17. La Fosse's involvement with the 'Seasons' commission and the pos-

sibility that he made, as Caylus said, preparatory drawings for the pictures, have been thoroughly discussed by Levey, op. cit.

18. The problem of the dates of Watteau's association with Crozat is treated by Levey, ibid., and excellently surveyed in A. Seilern, *Paintings and Drawings of Continental Schools other than Flemish and Italian at 56 Princes Gate, London, S.W.7*, London, 1961, p. 79.

19. The drawing is now in the Louvre (inv. 4675 bis). Watteau's use of it was already noted by Mariette (cf. D-V, III, pp. 43f., no. 87).

20. The derivations from Titian's *Andrians* are discussed by Levey, op. cit., p. 57. V. Miller, in 'The Borrowings of Watteau', *Burlington Magazine*, LI, 1927, p. 43, pointed out the borrowings from Rubens in the *Autumn*.

21. Cf. the discussion in Camesasca, op. cit., p. 103, no. 104.

22. E. de Goncourt (loc. cit.) already sensed the Veronesesque character of the pose in *A Lady at her Toilet*. Adhémar (p. 198) has suggested that it depends on an unknown drawing by Rubens.

23. See the literature cited in n. 18 above.

24. For Jullienne's *Recueil* see Dacier and Vuaflart (cited above, n. 3).

25. See below, n. 33.

26. Cf. Mathey, op. cit., p. 18, and F. Watson's review of Mathey's book, *Burlington Magazine*, CIV, 1962, p. 125.

27. See O. Brendel, 'The Interpretation of the Holkham Venus', *Art Bulletin*, XXVIII, 1946, pp. 65ff., especially p. 72, and U. Middeldorf's letter (ibid., XXIX, 1947, pp. 65ff.), where Brantôme is cited in connexion with Titian's 'Venuses'.

28. See G. Vasari, *Le vite de' più eccellenti pittori . . .* (ed. G. Milanesi), Florence, 1878, V, p. 418; F. Hartt, *Giulio Romano*, New Haven, 1958, I, p. 280.

29. For the painting see Adhémar, p. 218, no. 137, pl. 69, and Camesasca, op. cit., p. 105, no. 113; for Watteau's preparatory drawing, where the quiver does not appear, P-M, no. 854.

30. It is significant that, with one exception, prints after Watteau's drawings of nudes do not appear in Jullienne's publication, *Figures de différents caractères . . .* The exception is no. 105, which represents 'River Goddesses'. (It is illustrated in Mathey, op. cit., fig. 121.)

31. Caylus, in Adhémar, p. 182. In '*L'Enseigne de Gersaint. Aperçus nouveaux*', *Bulletin du laboratoire du Musée du Louvre*, no. 9, 1964, p. 17, n. 13, Adhémar suggests that the round picture of 'Bathers' seen in *Gersaint's Signboard* was one of the gallant paintings [*sic*] that Watteau

destroyed before he died. The suggestion seems most improbable to me.

32. E.g., C. Mauclair, *Le secret de Watteau*, Paris, 1942, p. 155: '*Voué au célibat et à une mort prématurée, il a abordé cette chair radieuse avec crainte et respect, il l'a transfigurée, purifiée.*' M. Eisenstadt, in *Watteaus Fêtes Galantes und ihre Ursprünge*, Berlin, 1930, pp. 167f., rightly criticized this fairly popular view of Watteau, and she called attention to remarks by Caylus that seem to contradict it. Eisenstadt's clarification of the erotic basis of Watteau's *fêtes galantes* is still insufficiently appreciated.

33. For the Crozat provenance of the picture, see Stuffmann, op. cit., pp. 134f., no. 182. Mercier's print was recorded by Mariette in 1731 (see D-V, III, p. 128, no. 306, with an illustration in vol. IV). For the probable date of the print see *Philip Mercier* (exhibition catalogue, compiled by R. Raines and J. Ingamells), City Art Gallery, York and Iveagh Bequest, Kenwood, 1969, p. 15. Adhémar (p. 136) mentions two paintings by Lavreince that apparently depend on Mercier's print. For the painted copy at Valenciennes see above, n. 4. A drawing by Watteau for the figure of the servant is known: P-M, no. 609.

34. E. Pilon, *Watteau et son école*, Paris, 1924, p. 116.

35. The drawing is P-M, no. 865. The painting is discussed in detail in D. Posner, 'Watteau's *Reclining Nude* and the "Remedy" Theme', *Art Bulletin*, LIV, 1972, pp. 383ff.

36. See, ibid., nn. 14, 15; E. de Goncourt, op. cit., pp. 90ff.

37. In this connexion, the round painting depicted in *Gersaint's Signboard* seems relevant. Cf. above, n. 31. J. Cailleux ('Four Artists in Search of the Same Nude Girl', *Burlington Magazine*, CVIII, 1966, April advertisement supplement, p. ii) has suggested that the source of a picture by Boucher is a painting of a sleeping girl that he attributes to Watteau. The attribution is, however, very doubtful.

38. Cf. N. Hampson, *The Enlightenment*, Harmondsworth, 1968, pp. 133f.; P. Gay, *The Enlightenment*, II, New York, 1969, pp. 192ff.

39. The most useful surveys are E. Fuchs, *Illustrierte Sittengeschichte*, 6 vols. Munich, n.d.; A. M. Rabenalt, *Mimus Eroticus*, 4 vols., Hamburg, 1965–7.

40. There is no critical consensus about the date of these works. Cf. Camesasca, op. cit., pp. 108f., 112, nos. 135, 157. Parker and Mathey (III, p. 345) have argued that all Watteau's erotic paintings were made at the time of the first version of the *Pilgrimage to Cythera*. Their dating is primarily based on a drawing (P-M, no. 772) which shows the maid who

159.4
W34p

appears in P-M no. 865 (our illustration 13) on the same sheet as two sketches of heads that were used in the *Pilgrimage*. However, considering Watteau's working habits, it is most likely that the heads were drawn long before the *Pilgrimage* was actually painted.

41. For Watteau's sketches from the male and female nude model that are connected to the 'Seasons' and related works, see P-M, nos. 511ff.

42. As reported by Caylus himself, in Adhémar, p. 179.

43. See S. Rochblave, *Essai sur le Comte de Caylus*, Paris, 1889; P. Champion, *Notes critiques sur les vies anciennes d'Antoine Watteau*, Paris, 1921, pp. 17ff., and pp. 75ff. where Caylus's biography of Watteau is reprinted and annotated. The final version of the biography is also reprinted in Adhémar, pp. 175ff.

44. Cf. R. Godenne, '*Agréable diversité des "Oeuvres badines" du Comte de Caylus*', *Dix-huitième siècle*, no. 1, 1969, pp. 251ff.

45. E. Rubin, 'On the Possible Re-dating of Caylus' Biography of Watteau', *Marsyas*, XIV, 1968-9, pp. 61f.

46. In Adhémar, p. 179.

47. Rubin, op. cit., p. 64; Champion, op. cit., p. 110, n. 6.

48. Not surprisingly, years later, as a scholar and collector of antiquities, Caylus was fond of 'indecent' objects of art. See *Correspondance inédite du Comte de Caylus avec le P. Paciaudi* (ed. C. Nisard), Paris, 1877, I, pp. 113f., 125.

49. Cf. Adhémar, pp. 106ff.

50. '*Hyr baet geen medisijn, waar het is soete pijn.*' For the painting see D. Hannema, *Beschrijvende Catalogus . . . Stichting Willem van der Vorm*, Rotterdam, 1962, p. 52.

51. '*J'ay la siringue en main, hastez vous donc, Madame,/De prendre pour le mieux ce petit lavement/Il vous refraischira, car vous n'estes que flame,/Et l'outil que je tiens entrera doucement.*' The print (Blum 1042) is one of a group of representations by Bosse of the 'Trades', and is often called 'The Apothecary'.

52. The version of the picture that was once in the Baron de Schwiter Collection was described in detail by E. and J. de Goncourt, *L'Art du dix-huitième siècle*, Paris, 1885, 'Notes and Additions to Boucher', pp. 20ff. The same or another version of this painting is illustrated in O. Brusendorff and P. Henningsen, *Love's Picture Book*, I, New York, 1969, p. 146. A fragment (the woman's head and upper body) of perhaps still another version was sold from the Zarine Collection at the Hôtel Drouot, 5 December 1917, no. 3.

53. Cf. Fuchs, op. cit., *Die Galante Zeit*, (I), pp. 150f., figs. 115–17.

54. Watteau seems at one moment to have thought along similar lines. In his drawing of the subject [13], the maid's head appears in three positions. One, the lowest on the sheet, shows her turning to look behind her, presumably at someone entering the room.

55. '*"La Toilette" par Antoine Watteau*', *La Revue de l'art ancien et moderne*, XXVII, 1910, pp. 35ff.

56. The first reading is given by G. Barker, *Antoine Watteau*, London, 1939, p. 177; the second by L. de Fourcaud, cited in n. 55, p. 35.

57. It must not be confused with the use of 'double meanings' or '*sous-entendus*', both very popular pictorial devices in the eighteenth century, which involve a layering of metaphorically connected meanings and not a juxtaposition of unrelated or even mutually exclusive readings.

58. A most important beginning in rectifying our idea of the content of Watteau's works is made in articles by A. P. de Mirimonde: '*Les sujets musicaux chez Antoine Watteau*', *Gazette des Beaux-Arts*, LVIII, 1961, pp. 249ff.; '*Statues et emblèmes dans l'oeuvre d'Antoine Watteau*', *La Revue du Louvre*, XII, 1962, pp. 11ff.

59. Essentially, this is what Caylus meant when he said that Watteau's '*compositions n'ont aucun objet*' (in Adhémar, p. 181). H. Bauer makes some interesting comments about this aspect of Watteau's works in '*Wo liegt Kythera*', *Wandlungen des Paradiesischen und Utopischen (Probleme der Kunstwissenschaft, II)*, Berlin, 1966, pp. 262ff., 270.

60. I am indebted to Mr Francis Watson of the Wallace Collection and to Mr Theodore Dell of the Frick Collection for information about bedroom furniture in Watteau's time.

61. The drawings that concern us are P-M, nos. 523 [29]; 524 [27]; 525 [26]; 526 [25]; 527 [28]; 528 [23]; 607 [22]. Also related to this group are P-M, nos. 522 [9] and 531.

62. In Adhémar, p. 179.

63. C. Vermeule, *European Art and the Classical Past*, Cambridge (Mass.), 1964, pp. 127f., figs. 103–4.

64. Cf. above, n. 22. A figure in Veronese's *Music* in the Marciana Library, Venice, strikingly parallels Watteau's woman in pose.

65. In Adhémar, p. 181.

66. Most scenes of nude women at their toilet, such as Jacopo Bellini's well-known picture in the Kunsthistorisches Museum, Vienna, were clearly meant as Vanitas images. Others, such as those showing a woman searching herself for fleas, were often designed to illustrate the 'sense of

touch'. Sometimes the woman who catches the flea is a prostitute and the picture meant as a warning of the danger awaiting men who yield to temptation. This is the case with Honthorst's *Flea Hunt* in the Basle museum (see J. Held and D. Posner, *17th and 18th Century Art*, New York, 1972, p. 226 and colorplate 30). Among more problematic toilet scenes with a nude woman is a lost painting by Jan van Eyck. J. Held has shown ('Artis Pictoriae Amator: An Antwerp Art Patron and his Collection', *Gazette des Beaux-Arts*, L, 1957, pp. 74ff.) that it cannot be, as L. Baldass thought (*Jan van Eyck*, London, 1952, pp. 84ff.), just a scene of daily life. Held's thesis is that it represents a ritual bath prior to marriage and that the picture may have been made for use as a cover for the *Arnolfini Wedding*. E. Panofsky, *Early Netherlandish Painting*, Cambridge (Mass.), 1953, I, pp. 3, 362, 440, comments on its possible relationship to depictions of magical practices.

Also puzzling are the paintings made by François Clouet and his followers of nude women in their baths. They are evidently portraits, usually thought to be of Diane de Poitiers, Gabrielle d'Estrées, or other famous women of the time. These works have been discussed recently by R. Trinquet, whose argument that they are political satires is intriguing but not conclusive: '*L'Allégorie politique au XVI^e siècle: la "Dame au Bain" de François Clouet*', *Bulletin de la Société de l'Histoire de l'Art Français*, 1966 [1967], pp. 99ff.; '*L'Allégorie politique dans la peinture française au XVI^e siècle: Les "Dames au Bain"*', ibid., 1967 [1968], pp. 7ff. Probably some of them, as well as related toilet scenes that do not involve bathing, are to be interpreted as allegories of love and fertility.

67. In a book published in 1631 – a kind of atlas of the courtesans of Europe – an English harlot, 'Margery of Richmonde', is shown, exactly like the woman in Everdingen's painting [30], half-length, bare-breasted, combing her hair. See Fuchs, op. cit., *Die Renaissance* (1), p. 425, fig. 367; also S. Slive, *Frans Hals*, London, 1970, I, pp. 91f. Rubens, in the Vienna *Feast of Venus*, showed courtesans holding a comb and a mirror. See P. Fehl, 'Rubens's "Feast of Venus Verticordia"', *Burlington Magazine*, CXIV, 1972, p. 161.

68. See the brief but illuminating discussion by E. Haverkamp-Begemann, 'Terborch's Lady at her Toilet', *Art News*, LXIV, December 1965, pp. 38ff.

69. See G. de Tervarent, *Attributs et symboles dans l'art profane*, Geneva, 1958–59, col. 273; also G. Hartlaub, *Zauber des Spiegels*, Munich, 1951, *passim*.

70. Another Netherlandish work which has a striking affinity to Watteau's picture is a painting of 1650 by Jacob van Loo that shows a woman from behind, naked but for a nightcap, entering her bed while she looks back invitingly over her shoulder at the spectator. In this picture the string of pearls on the night-table, and the woman's unabashed nudity and solicitation of the spectator identify her as a prostitute. The image allows, if it does not provoke, a 'moral' response similar to the other Netherlandish brothel and courtesan pictures we have discussed. Van Loo's painting, now in the museum at Lyons, had a certain celebrity in France in the later eighteenth century, but there is no evidence that Watteau knew it. See R. Jullian, 'Le "Coucher à l'italienne" de Jacob van Loo', *Proporzioni*, III, 1950, pp. 199ff.

71. W. Stechow, 'Nicolas Knupfer's *Venus* at Richmond: Wanderings of a Motif', *Art in America*, XXVIII, 1940, pp. 162ff.

72. The head in Steen's painting has been interpreted as a cherub's head, and the suggestion has been made by C. W. de Groot that the opposition of heavenly and earthly realms is therefore symbolized in the picture. (Cf. [Mauritshuis], *Catalogus Jan Steen Expositie*, The Hague, 1958-9, no. 25.) But surely Steen would have used a less ambiguous motif if he wished to symbolize heaven. The same motif, with an unequivocally 'earthly' meaning, was used by Jordaens, also above a doorway, in his *Fruit-Seller* in the Glasgow Art Gallery.

73. Op. cit., p. 35. Cf. Mirimonde, '*Statues et emblèmes*' (cited above, n. 58), p. 18, n. 21.

74. The idea of a gilded cupid on the headboard of a bed is strikingly paralleled in Rembrandt's *Danaë* (Hermitage), once in the Crozat Collection (but only after 1740). If I am right in thinking that Titian's *Danaë* [10] inspired Watteau, then it is possible that Watteau borrowed from Rembrandt's version of the same theme if he knew it.

75. Cf. the illustrations to J. Held's 'Flora, Goddess and Courtesan', *Essays in Honor of Erwin Panofsky*, New York, 1961, pp. 201ff.

76. Stuffmann, op. cit., p. 80, no. 179.

77. Guercino's design was almost certainly unknown to Watteau. Mr Denis Mahon kindly informed me that during Watteau's lifetime the drawing was in the Casa Gennari in Bologna, and that there is no evidence of its having been copied. Furthermore, no other known version of the theme by Guercino includes the motif of putting on the chemise. Mr Mahon identifies the drawing as the one that was described in the Casa Gennari inventory of 1719 as a drawing '*d'acquarella d'alcune Femine*

che si levano da letto con un' Amorino'.

78. Reported in the (possibly spurious) *Mémoires de Madame du Hausset, femme de chambre de Madame de Pompadour*, Paris, 1842, p. 59.

79. Interestingly, a picture by Steen in the Rijksmuseum (formerly De Bruyn Collection), a variant or possibly a preparatory study for *The Morning Toilet* [32], that contains no moralizing elements also has no specific connexion to courtesan imagery and no erotic content. (Cf. *Catalogus Jan Steen Expositie* [cited above, n. 72], no. 20, fig. 22; K. Roberts, 'Dutch Paintings at the Queen's Gallery', *Burlington Magazine*, CXIII, 1971, p. 353.)

80. On pet dogs in the eighteenth century, see A. Franklin, *La vie privée d'autrefois: les animaux*, Paris, 1899, pp. 143ff.; J. Grand-Carteret, *L'Histoire, la vie, les moeurs et la curiosité*, Paris, 1927-8, IV, p. 160.

81. For the meaning of Fragonard's painting, see W. Sauerländer, '*Über die Ursprüngliche Reihenfolge von Fragonards "Amours des Bergers"*', *Münchner Jahrbuch der Bildenden Kunst*, XIX, 1968, p. 148; and further, D. Posner, 'The True Path of Fragonard's "Progress of Love"', *Burlington Magazine*, CXIV, 1972, p. 530.

82. Cf. M. Schapiro, '*Les pommes de Cézanne*', *Revue de l'art*, nos. 1-2, 1968, p. 78 and n. 30. Slive, incidentally, points out that in Netherlandish brothel and inn scenes dogs frequently appear as symbols of unchastity and gluttony (op. cit., I, p. 73).

83. Cf. T. Garzoni, *La piazza universale di tutte le professioni* . . . , Venice, 1595, p. 599.

84. A number of writers have rejected the traditional interpretation of the women as prostitutes. However, the only alternative so far proposed that would account for most of the elements in the picture identifies the women as Circe-like witches who 'convert men into unconscious beasts', which, at least in our context, is not very different. (Cf. M. Cancogni and G. Perocco, *L'Opera completa del Carpaccio* [Classici dell'arte], Milan, 1967, p. 88, no. 12.)

85. The theme is not uncommon in Dutch seventeenth-century painting. In a picture by Metsu in the De Young Museum, San Francisco, for instance, a dog 'dances' to the tune his mistress plays on a viola da gamba, an instrument frequently associated with love.

86. For comments about such dogs (called '*lexicons*' in the parlance of the time) in life and art in the eighteenth century, see A. Girodie, *Jean-Frédéric Schall*, Strasbourg, 1927, p. 20; and Fuchs, op. cit., *Die Galante Zeit* (1), p. 79, (2), p. 121, and illustrations after pp. 144, 152.

87. Adhémar (p. 104), for instance, puts the *Lady at her Toilet* '*à l'origine de toutes les oeuvres du XVIIIᵉ siècle, dans lesquelles l'érotisme est de plus en plus prononcé*'.

88. A scene of a woman at her bath by N. R. Jollain was also probably inspired by Watteau's painting. Jollain's picture is known in a painted version (Musée Cognac-Jay), from a print by Bonnet, and from a piece of Chinese export porcelain (illustrated in G. Savage, *French Decorative Art, 1638-1793*, New York-Washington, 1969, pl. 88).

89. Cf. Adhémar, pp. 145ff.; C. Duncan, *The Persistence and Re-Emergence of the Rococo in French Romantic Painting* (unpublished Ph.D. dissertation) Columbia University, New York, 1969, pp. 2, 36ff., 56ff.

90. For a general discussion of the role of Watteau's art in the formation of French Romantic culture, see S. Simches, *Le romantisme et le goût esthétique du XVIIIᵉ siècle*, Paris, 1964.

91. Delacroix's *La femme aux bas blancs* (Louvre) is a picture that one might imagine to have been inspired by Watteau's painting.

List of Illustrations

Color plate and title page: *A Lady at her Toilet*. By Antoine Watteau, *c*. 1716–17. Oil on canvas, 44 x 37 cm. London, The Wallace Collection. (Photo: By permission of the Trustees of the Wallace Collection.)

14. *Susanna at her Bath*. By Jean-Baptiste Santerre, 1704. Paris, Louvre. (Photo: Alinari.)

15. *Woman in Bed Illuminated by Candlelight*. By Antoine Pesne, 1718. Mosigkau bei Dessau, Castle. (Photo: Courtesy Dr Ekhart Berckenhagen.)

16. *The Intimate Toilet*. By an anonymous French engraver, early eighteenth century. (Photo: From Fuchs, *Illustrierte Sittengeschichte*.)

17. *The Foot Bath*. Engraving by N. Bazin, 1685, after Dieu de Saint-Jean. (Photo: Bibliothèque Nationale.)

18. *The Doctor's Visit*. By Jan Steen, *c.* 1665. Rotterdam, Willem van der Vorm Foundation. (Photo: Boymans van-Beuningen Museum.)

19. *The Remedy* ('The Apothecary'). By Abraham Bosse, 1633. (Photo: The Metropolitan Museum of Art, Harris Brisbane Dick Fund.)

20. *The Remedy* ('The Officious Servant'). Engraving by A. Chapponier, 1786, after Jean-Frédéric Schall. (Photo: Bibliothèque Nationale.)

21. *A Lady Getting out of Bed*. By Nicolas Lavreince, 1776. Stockholm, Nationalmuseum. (Photo: Nationalmuseum.)

22. *Study of a Woman Reclining on a Chaise Longue*. By Antoine Watteau, *c.* 1716-17. Black and red chalks on cream paper, 21 x 31 cm. Paris, Fondation Custodia. (Photo: Fondation Custodia.)

23. *Study of a Semi-Nude Woman Reclining on a Chaise Longue*. By Antoine Watteau, *c.* 1716-17. Black, red and white chalks on cream paper, 17·8 x 21 cm. Los Angeles, Norton Simon Foundation. (Photo: Norton Simon Foundation.)

24. *Pardo Venus*, detail. By Titian, before 1567. Paris, Louvre. (Photo: Alinari.)

25. *Study of a Semi-Nude Woman Seated on a Chaise Longue*. By Antoine Watteau, *c.* 1716-17. Black and red chalks on white paper, 34·1 x 22·1 cm. London, British Museum. (Photo: British Museum.)

26. *Study of a Woman Wearing a Chemise*. By Antoine Watteau, *c.* 1716-17. Black, red and white chalks, 16·5 x 17·8 cm. London, Mrs Florence Gould Collection. (Photo: Nationalmuseum, Stockholm.)

27. *Study of a Woman Wearing a Chemise*. By Antoine Watteau, *c.* 1716-17. Black, red and white chalks, 14·8 x 19·6 cm. Paris, Marquis Hubert de Ganay Collection. (Photo: Giraudon.)

28. *Study of a Woman Wearing a Chemise*. By Antoine Watteau, *c.* 1716-17. Black, red and white chalks on buff paper, 17·5 x 20·6 cm. Los Angeles, Norton Simon Collection. (Photo: Norton Simon Foundation.)

29. *Study of a Nude Woman Seated on a Chaise Longue*. By Antoine Watteau, *c.* 1716-17. Black and red chalks on grey-blue paper, 22·5 x 25·4 cm. London, British Museum. (Photo: British Museum.)

30. *A Courtesan at her Toilet*. By Caesar van Everdingen, mid seventeenth century. Formerly The Hague, Steengracht Collection. (Photo: Bruckmann.)

31. *A Courtesan at her Toilet*. By Michael Sweerts, *c.* 1645. Rome, Galleria dell'Accademia di San Luca. (Photo: Gabinetto Fotografico Nazionale.)

32. *The Morning Toilet*. By Jan Steen, 1663. London, Buckingham Palace. (Reproduced by gracious permission of H.M. the Queen. Photo: A. C. Cooper, Ltd.)

33. *Nude Woman with Cupid*. By Nicolas Knupfer, mid seventeenth century. Formerly Richmond, Cook Collection. (Photo: Anderson.)

34. *Brothel Scene*. By an anonymous Dutch engraver, early seventeenth century. (Photo: From Fuchs, *Illustrierte Sittengeschichte*.)

35. Study for a *Toilet of Venus*. By Guercino, *c.* 1625. Destroyed. Formerly Bremen, Kunsthalle. (Photo: Kunsthalle.)

36. *The Judgement of Paris*, detail. By Antoine Watteau, *c.* 1720. Oil on panel. Paris, Louvre. (Photo: Alinari.)

37. *Love and Friendship*, detail. By Jean-Honoré Fragonard, 1771–3. New York, The Frick Collection. (Photo: Copyright the Frick Collection.)

38. *Courtesans on a Balcony*. By Vittore Carpaccio, *c.* 1490. Venice, Correr Museum. (Photo: Alinari.)

39. *Fête in a Park*, detail. By Antoine Watteau, *c.* 1718. Oil on canvas. London, The Wallace Collection. (Photo: The Wallace Collection.)

40. *Fête in a Park*, detail. By Antoine Watteau. London, The Wallace Collection. (Photo: The Wallace Collection.)

41. *The Dutch Awakening*. Engraving by F. Basan, third quarter of the eighteenth century, after Frans van Mieris I. (Photo: British Museum.)

42. *Toilet Scene*, detail. By Nicolas-François Regnault, *c.* 1778. London, The Wallace Collection. (Photo: The Wallace Collection.)

43. *The Ring-Biscuit*. Engraving by Bertony, 1783, after Jean-Honoré Fragonard, *c.* 1770. (Photo: Bibliothèque Nationale.)

44. *Studies of a Woman*, detail. By Antoine Watteau, *c.* 1715. Black, red and white chalks on cream paper, 25·8 x 20·8 cm. Paris, Private Collection. (Photo: Institute of Fine Arts.)

45. Detail of 32.

46. *Summer*. By Nicolas Lancret, *c.* 1725. Leningrad, Hermitage. (Photo: Bruckmann.)

47. *The Charming Hiding-Place*. By Jean-Frédéric Schall, *c.* 1783. Formerly Paris, G. Alexis-Godillot Collection. (Photo: From Girodie, *Jean-Frédéric Schall*.)

Index

Bold numbers refer to illustration numbers

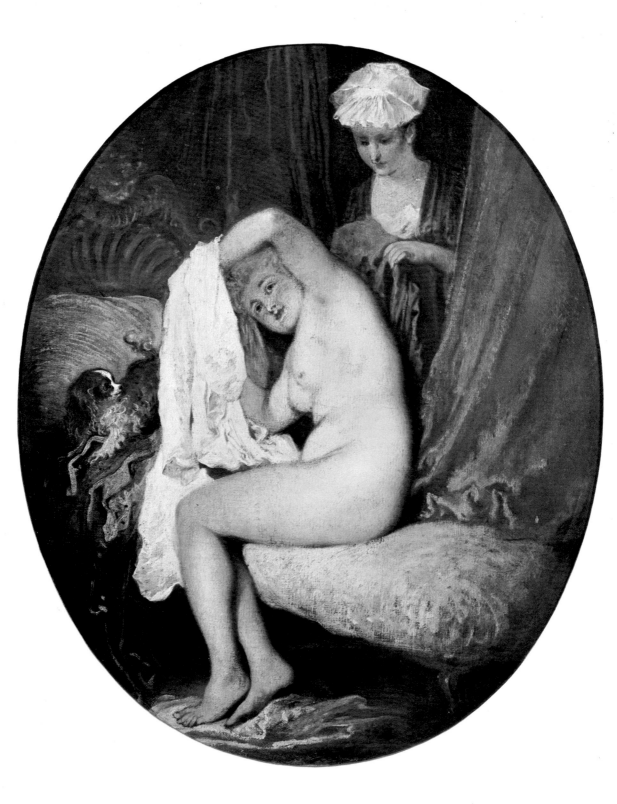